W9-AAA-737

On

hop

Focus on Adobe
Photoshop

The *Focus On* Series

Photography is all about the end result—your photo. The *Focus On* series offers books with essential information so you can get the best photos without spending thousands of hours learning techniques or software skills. Each book focuses on a specific area of knowledge within photography, cutting through the often confusing waffle of photographic jargon to focus solely on showing you what you need to do to capture beautiful and dynamic shots every time you pick up your camera.

Titles in the *Focus On* series:

Focus On
Adobe Photoshop

Corey Hilz

AMSTERDAM • BOSTON • HEIDELBERG • LONDON • NEW YORK • OXFORD • PARIS
SAN DIEGO • SAN FRANCISCO • SINGAPORE • SYDNEY • TOKYO

Focal Press is an Imprint of Elsevier

Focal Press is an imprint of Elsevier
225 Wyman Street, Waltham, MA 02451, USA
The Boulevard, Langford Lane, Kidlington, Oxford, OX5 1GB, UK

Notices
Knowledge and best practice in this field are constantly changing. As new research and experience broaden our understanding, changes in research methods, professional practices, or medical treatment may become necessary.

Practitioners and researchers must always rely on their own experience and knowledge in evaluating and using any information, methods, compounds, or experiments described herein. In using such information or methods they should be mindful of their own safety and the safety of others, including parties for whom they have a professional responsibility.

To the fullest extent of the law, neither the Publisher nor the authors, contributors, or editors, assume any liability for any injury and/or damage to persons or property as a matter of products liability, negligence or otherwise, or from any use or operation of any methods, products, instructions, or ideas contained in the material herein.

Library of Congress Cataloging-in-Publication Data
Application Submitted

British Library Cataloguing-in-Publication Data
A catalogue record for this book is available from the British Library.

ISBN: 978-0-240-81220-5

For information on all Focal Press publications
visit our website at www.elsevierdirect.com

11 12 13 14 15 5 4 3 2 1

Printed in China

Typeset by: diacriTech, Chennai, India

Working together to grow
libraries in developing countries

www.elsevier.com | www.bookaid.org | www.sabre.org

ELSEVIER BOOK AID International Sabre Foundation

About the Author

Corey Hilz is a professional photographer specializing in nature and travel photography. His work is seen in magazines, books, calendars, and catalogues, as well as in art galleries. Corey finds that diversity in nature offers boundless opportunities for new images. He approaches his subjects with an artistic eye, looking for a fresh perspective. Corey has a passion for helping others improve their photography by sharing his knowledge through group and private instruction. He leads workshops to locations in the United States and abroad. See more of Corey's photography on his website: coreyhilz.com.

Contents

3 **Chapter 1: Bridge: Importing, Organizing, and Initial Editing**

4 Bridge layout

7 Workspaces

8 Setting up a Favorites folder

9 Creating the metadata template

10 Downloading photos

15 Organizing

20 Initial editing

21 Deleting and rejecting photos

22 Ratings and labels

23 Rotating photos

24 Checking focus

25 Review mode

27 Conclusion

29 **Chapter 2: Camera Raw: Standard Adjustments**

32 Opening multiple photos

34 Checking focus

36 Crop tool

38 Proportional cropping

39 Straighten tool

43 Spot Removal tool

46 Red-Eye Removal tool

48 Basic panel

67 Conclusion

69 **Chapter 3: Camera Raw: Advanced Adjustments**

70 Tone Curve

73 HSL/Grayscale

77 Adjustment Brush

83 Graduated Filter

85 Lens Corrections

91 Conclusion

93 **Chapter 4: Metadata and Keywords**

94 Metadata groups

96 Metadata Templates

99 Skip the templates

100 Keywords

105 Searching

106 Batch Rename

107 Conclusion

109 Chapter 5: Photoshop: Global Adjustments

110 Toolbox

111 Options Bar

111 Layers panel

112 Adjustment Layers

116 Adjustments panel

117 Common adjustments

136 Converting to black and white

138 Smart filters

140 Shadows/Highlights

141 Lens Correction

142 Conclusion

145 Chapter 6: Photoshop: Selective Adjustments and Retouching

146 Brushes

147 Brush shortcuts

147 Brush hardness

148 Opacity

149 Flow

149 Opacity + Flow

150 Using layer masks with adjustment layers

154 Working with Opacity and Flow

155 Selections: Shortcuts to layer masks

159 Selectively lightening and darkening

162 Retouching

168 File saving and file formats

173 Chapter 7: Sharing Your Images: Exporting Photos, Slide Shows, Web Galleries, and PDFs

174 Exporting

174 Facebook and Flickr

176 Save to Hard Drive

177 Presets

179 Slide shows

180 Web galleries and PDFs

182 Web gallery

187 PDF

192 Conclusion

195 Chapter 8: Printing

217 Conclusion

218 Subject Index

Introduction

ORGANIZING AND EDITING are key parts to the process of digital photography. However, we don't want to spend an exhaustive amount of time working with our photos on the computer. When you're capturing hundreds or thousands of photographs, having a streamlined workflow to process them is important. If you're like me, you don't want to spend more time on the computer than you have to. Being efficient with your time will allow you to get the most out of your photos in the least amount of time. This book will take you step by step through a workflow using Adobe Bridge, Camera Raw, and Photoshop to edit, organize, selectively adjust, and print your photographs. We won't examine every feature of these applications but will instead focus on those that are the most useful, making your tasks of editing and organizing easier.

Chapter 1: Bridge: Importing, Organizing, and Initial Editing

ADOBE BRIDGE IS THE PLACE to begin your digital workflow. Bridge will be the hub for working with your photographs. You'll use Bridge to organize your photos, import new photos, review technical data, create slide shows, and more. When you're ready to adjust and enhance your photos, you can go directly from Bridge to Camera Raw or Photoshop. So no matter whether you want to rearrange your photos or edit them, Bridge is the place to start.

In this chapter we'll first become familiar with the layout of Bridge and where to find things; then we'll go through the process of importing images. Later in the chapter, we'll explore the organizing features and learn how to perform the initial editing of our photos.

Bridge layout

When you open Adobe Bridge, you'll see the default workspace (how all the information is laid out), which is made up of various panels, each with its own type of information. These panels are arranged in three sections: left, middle, and right. On the left are Favorites, Folders, Filter, Collections, and Export. The middle is just the Content panel. And on the right are the Preview, Metadata, and Keywords panels.

Bridge gives you a lot of control over how the panels are arranged. For example, you're able to move and resize the panels. Separating the various panel sections are thin vertical and horizontal bars. These bars are used to resize the panels.

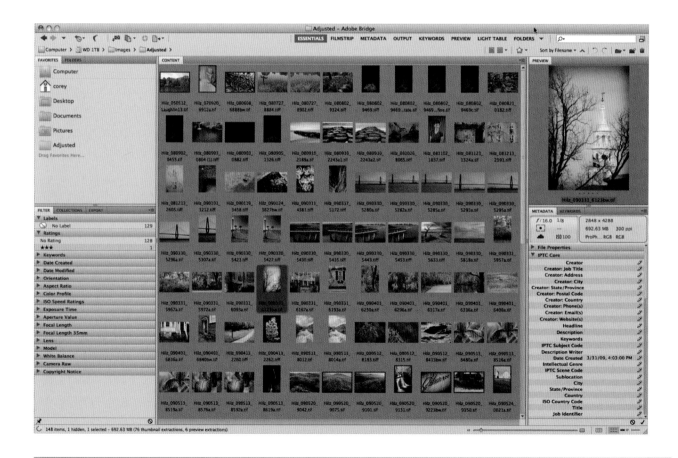

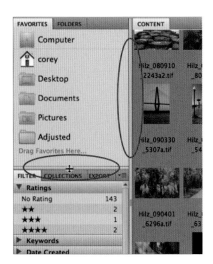

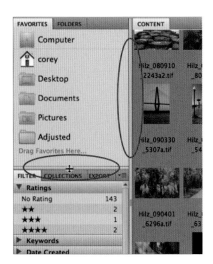

You can also move the panels to different locations with a click and drag. Click and drag a panel's name tab and then drop the panel in its new location. Let's take a look at how the panels can be rearranged to get a better idea of what you can do with them.

To change the size of a panel, first move your mouse pointer to one of these bars. The mouse pointer changes to a vertical or horizontal line with a double-arrow. Next, click and drag the bar to make the panel bigger or smaller. For example, to change the panel's width, drag the vertical bar left or right. To adjust the panel's height, drag the horizontal bar up or down.

You can have up to three sections of panels: left, center, and right (like with the default layout). They can be grouped together or stacked. If panels are grouped, then Bridge places the panel tabs next to each other. With this arrangement you can see only one of the panels at a time. To switch between panels, click on the name of the panel you want to see.

Three panels grouped together. The Filter panel is selected, making its contents visible. The contents of the other panels (Collections and Export) are hidden behind the Filter panel.

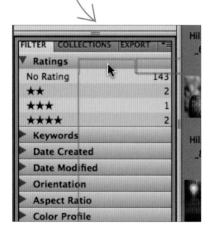

To group panels together, you drag and drop one panel on top of another (click and drag the panel name). When you drag one panel over another, a blue outline will appear around the panel you're dropping it onto.

Now let's find out how to stack panels. When panels are stacked, you're able to have multiple panels visible at once. Each panel has its own area in the left, right, or center sections. In the default view, there are two panels stacked on the left and right. Because you can move panels, you're able to change how they're stacked. If you want to stack a panel in a new location (different from grouping it with another panel), you have to be careful where you drag and drop it. Instead of dragging one panel on top of another, you drag it to the divider line that's just above the panel where you want it to go. When you do this, you'll see a blue line appear above the panel. This tells you the panel you're moving is going to be placed above the existing panel.

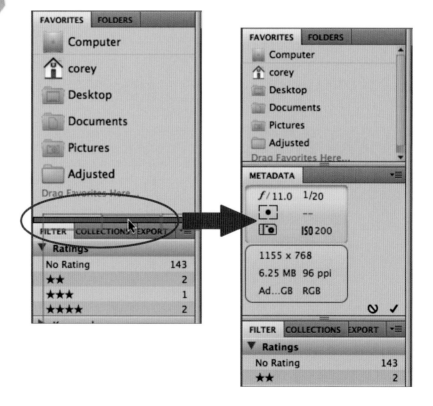

Cluttered Panels

Although you can stack many panels, the Bridge layout will quickly become cluttered because all these individual panels will be small and you won't be able to see much of the information in them. I recommend not having more than two panels stacked per section (left, center, right). Instead, group additional panels so you have easy access to them, but avoid a jumbled display.

Workspaces

Bridge also comes with additional presets for the locations of the panels that are called *workspace layouts*. How you access the layouts depends on which version of Bridge you are using.

If you're using CS3, look at the bottom right of the Bridge window where you'll see three small boxes numbered 1, 2, and 3. Clicking on each of these boxes changes the workspace layout. To select the layout with which each number is associated,

click and hold (or right-click) on the number to bring up a list of layouts.

If you're using CS4 or later, the workspace layouts have been moved to the top right of the window, where they're listed by name. The workspaces available vary by version (CS4 versus CS5). For example, here's what is included for CS5: Essentials,

Filmstrip, Metadata, Output, Keywords, Preview, Light Table, and Folders. Click on a workspace name to switch layouts. You may not be able to see the names of all the workspaces initially. At the end of the list of workspaces is an arrow. Click on it to see a list of all the workspaces; then select the one you want. Alternatively, to the left of the first workspace name are two columns of dotted lines. Click and drag them to the left to reveal the rest of the workspaces.

You can click and drag the names of the workspaces to reorder them.

Setting up a Favorites folder

In the default workspace, the panels in the top-left group are Favorites and Folders. You can choose which folders you want to have in the Favorites panel. This is the place to put the folders you will access most often when working with your photographs so you don't have to go digging through layers of folders on your computer every time.

FIND AND ADD FOLDERS TO THE FAVORITES PANEL

1. Click on the Folders tab. You'll see a list with your computer and/or hard drives.

2. Look through the hierarchy of the folders on your computer/hard drives to find the folder you want.

3. When you've found the folder, click on the name of the folder; then go to File>Add to Favorites. When you go back to the Favorites panel, the folder will be listed there. Repeat this process to add as many folders as you want to your Favorites.

If there is a folder shown in the Content panel that you want as a favorite, you can drag it directly to the Favorites panel.

To remove a folder from the Favorites panel, click on the folder; then go to File>Remove from Favorites.

NAVIGATING THE FOLDERS PANEL

- Click on the arrow next to the computer/hard drive name to show a list of the folders within it.
- Click on the arrow next to a folder to see the folders inside it.
- If you want to check what's in a particular folder, click the folder name and its contents will appear in the center of the Bridge window (Content panel).
- To hide what's inside a folder, click the arrow again.

Flyout menu icon

Creating the metadata template

To make the workflow smoother later, we're going to prepare some information in Bridge first. We'll begin by creating a metadata template that we'll use when downloading photos from a memory card.

In Bridge, find the Metadata panel. If it's not visible, go to Window>Metadata Panel. At the top-right corner of the Metadata panel, click on the small gray triangle to bring up the flyout menu. The icon for the flyout menu can be hard to see because it almost blends in with the Bridge background.

In the flyout menu, select Create Metadata Template. We're going to create a template that includes your name and contact information. When we start to download photos, we'll be able to use this template to have this information automatically added to each picture. I like to add this information because it identifies me as the photographer and gives people a way to contact me if they come across my photograph.

Flyout menu for Metadata panel

1. Give the template a descriptive name such as Basic Information or Contact Information.

Template Name: | Basic Information

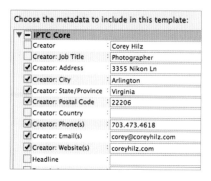

2. We're going to add information only to the IPTC Core section. IPTC stands for International Press Telecommunications Council, but there's no need to memorize that; it's just the title for this group of metadata. This section includes fields such as Creator, Job Title, Address, and City. If you don't see such a list, click the disclosure triangle next to the words *IPTC Core*. Fill in the following fields, which are related to contacting you: Creator, Address, City, State/Province, Postal Code, Country, Phone(s), Email(s), Website(s), and Copyright Notice. We'll revisit metadata later in the workflow, but right now we just want a set of information that will apply to all your photos.

3. Click Save.

Downloading photos

Now it's time to download images from a memory card. We'll use Bridge to copy the photos from the memory card to the computer. Go to File>Get Photos from Camera. This will launch the Photo Downloader.

If you haven't used the Photo Downloader before, you'll first see a message asking whether you want Photo Downloader to launch every time you connect your camera or put a card in your card reader.

Once the Photo Downloader has launched, click the Advanced Dialog button in the bottom-left corner. Clicking this button expands the window to give us more options. Let's go through the options in the Photo Downloader dialog box.

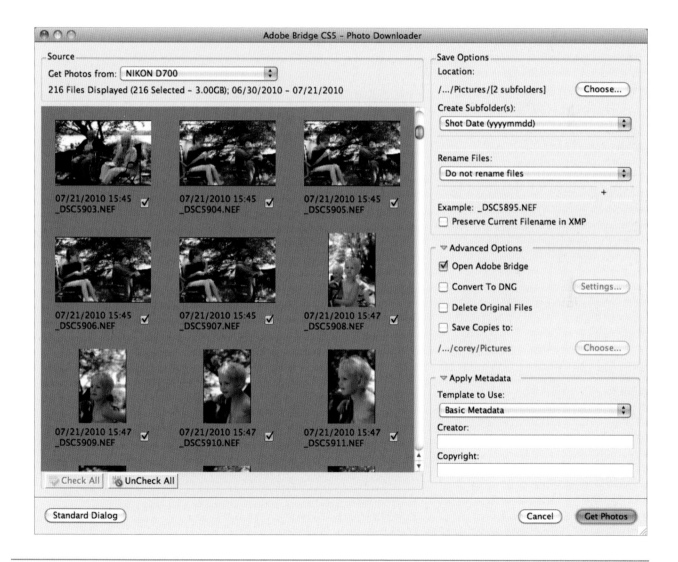

Source section

Use the Source drop-down menu to choose the name of your camera. Even if you are using a card reader, the memory card will be listed as the name of the camera. If your camera's name is not listed, choose <Refresh List> and see whether it appears.

The top of the Source section shows the camera selected as well as how many files are on the card, how many are selected, how much space the selected photos will take up, and the date range over which the photos on the memory card were taken.

In the left half of the dialog box are thumbnails of the photos on your memory card. By default, all the photos on your memory card will be downloaded. For any photos you don't want downloaded, click the checkbox below the photo. You can also use the buttons below the thumbnail area to check or uncheck all the photos.

Save Options section

Location

Under Location, click Choose to select the folder on your computer where you want your photos downloaded. Downloading your photos to the same place every time works well. This way, you have a central location for all your pictures. A folder named Pictures or Photos works well for this purpose.

To check/uncheck multiple photos at once, select them all first; then click the checkbox for just one of the selected photos. This will check/uncheck all the selected photos.

Create Subfolder(s)

The Create Subfolder(s) option allows you to automatically organize your photos right when you download them. Click on the drop-down menu to see your choices. If you want all your photos downloaded directly into the folder chosen for Location, then select None. The other choices will create subfolders within the main folder chosen for Location.

The subfolder options are choices for how you want to name the folders. Custom Name will allow you to enter the name of the subfolder where your photos will be downloaded. For instance, you may choose the custom

name Italy if all your photos were taken on a trip to Italy. The choices that begin with Shot Date are variations on using the date the picture was taken for the folder name. If you have photos on your memory card that were taken on different days, the Photo Downloader will create a separate subfolder each day.

Rename Files

You can rename your photos instead of keeping the letters and numbers your camera uses to name them. There are many combinations to choose from in the Rename Files drop-down menu. I prefer to rename my files when I download them. I use a naming structure that ensures I won't end up with two photos with the same filename. I use the following option: Custom Name + Shot Date (yymmdd).

In the Custom Name field, I use my last name as a way to identify it as one of my photos. You could also use your initials if you have a long last name. Including the date lets me see at a glance when the photo was taken. I use the "yymmdd" format because that keeps the photos in chronological order when they're sorted by name in a folder. At the end of the filename is a four-digit number. This will count up from 1 by default. If you are downloading multiple memory cards, the start number will automatically change to continue counting where the last sequence left off. For example, if you download 100 photos, they'll be numbered 1 to 100. When you put in the next memory card, the count will automatically begin at 101. Of course, you can always change the number.

My file renaming convention

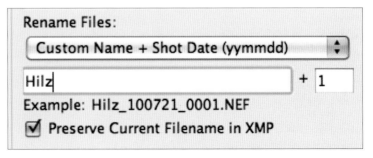

If you choose to rename your files, check the box for Preserve Current Filename in XMP. This way, you'll always have the original filename available if you need to reference it. XMP stands for Extensible Metadata Platform. It's a type of file that stores information, such as settings, about your photo.

Advanced Options section

In the Advanced Options section, check Open Adobe Bridge. When you do, Bridge will show you the photos after the download is complete, allowing you to continue the editing process.

You don't need to convert your files to the Digital Negative (DNG) format. If you'd like to, click the Settings button to see the options for DNG conversion.

I recommend **not** checking Delete Original Files. I prefer to always erase my memory card using the format/erase function in my camera. This way, the camera will set up the necessary folders on the memory card so that it accurately stores the photos.

Checking the *Save Copies to:* option is a way to automatically create backup copies of the photos you are downloading. It's important to have a backup system for your photographs. Because there are no negatives to go back to with digital photos, having at least one backup copy of all your photographs is essential. If you have only one copy and something happens to your hard drive, your photos will be lost. This option gives you a quick and easy way to make sure your photos are backed up from the moment you import them. If you don't already have a backup system in place, using *Save Copies to:* is a convenient way to make sure you have that all-important backup.

Click the Choose button to select the location for the backup copy of your photos. The location should be on a different hard drive from what you selected in the Location section previously. External hard drives are great to use for backups. Placing your backup on the same hard drive and the original files doesn't do you any good.

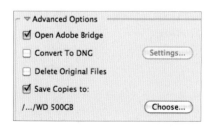

Apply Metadata section

In the Apply Metadata section, you select the metadata template created earlier. Click the drop-down menu and choose the name you gave the template (I used Basic Information). You don't need to fill in the Creator or Copyright fields because that information is already entered in the template.

Choose a previously created metadata template

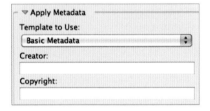

Organizing

Let's look at a few features in Bridge that help us with organizing our photos.

Sorting

Sorting controls how the thumbnails (Content panel) are organized. You can choose from many criteria for sorting your photos, including filename, dimensions, date created, and rating. These options make it easier to find photos based on certain criteria. For instance, if I'm looking for a vertical image to use on my website, I can sort by dimension, which will separate the horizontals from the verticals. Then I can look at all the verticals together instead of sifting through the horizontals as well.

To choose the sorting method, go to the Sort pop-up menu in the top right of the Bridge window. These options are also available in the menus under View>Sort.

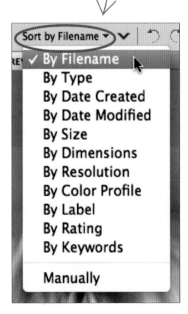

You can always rearrange the thumbnails manually by clicking and dragging them. If you do so, the sort option will automatically change to Manually. Next to the Sort button is an arrow that points either up or down. This arrow controls whether the photos are sorted in ascending (up) or descending (down) order. Click the arrow to switch the order.

Collections

The Collections panel offers a flexible way to group photos. Collections are great for long-term or short-term grouping of your photos because you can easily gather photos from various folders. This panel is usually on the left side of the window. However, all workspaces don't show the Collections panel. If you don't see it, go to Window>Collections Panel. To create a collection, click the New Collection button at the bottom of the Collections panel and then give it a name.

Collections tips, Part 1

- Collections hold virtual copies of your photos. To add photos to a collection, drag them from the Content panel to the collection. The number of photos in the collection is shown in parentheses next to the collection name.

- When you put a photo in a collection, it is not actually moved; the file stays in its original folder. Bridge simply makes a note of which collection(s) the photo should appear in. You can place the same photo in multiple collections because Bridge doesn't actually move the photograph.

Collections panel

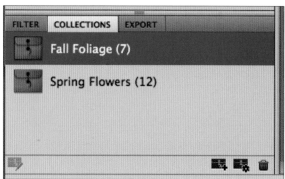

Collections tips, Part 2

- To remove photos from a collection, go to the collection and select the photos you want to remove. Then click the Remove From Collection button at the top of the Content panel. The photos will disappear from the collection. Don't worry; the photos aren't deleted on your computer—just removed from the collection. They're still in the folder you initially dragged them from (as well as any other collections you placed them in).

- If you **do** want to delete a photo directly from a collection, press Command-Delete (PC: Control-Delete). You can also reject photos from collections using Option-Delete (PC: Alt-Delete).

- In the Content panel, select the photos that you want to have in the new collection.
- Click the New Collection button at the bottom of the Collections panel.
- Click Yes when Bridge asks if you want to include the selected files in the collection.

Smart Collections

Smart collections are another type of collection you can create within the Collections panel.

- How they're the same as regular collections: The photos they hold have not been moved; they are still in their designated folders.

- How they're different from regular collections: You don't add photos to a smart collection by dragging and dropping. Bridge finds the photos for the smart collection based on search criteria you choose.

- Smart collections are basically saved searches.

To create a smart collection, click the New Smart Collection button at the bottom of the Collections panel.

In the Smart Collection box that pops up, there are three sections: Source, Criteria, and Results.

- **Source:** Choose which folder will be searched.

- **Criteria:** Select the information you want to use to find photos. You can search for photos based on Ratings, Labels, Keywords, and much more. To use multiple criteria, click the plus sign to the right of the first criteria item (the minus sign deletes criteria). You can choose one, two, five, or more criteria. It's up to you how general or specific the search is.

- **Results:** Choose whether a photo needs to have "any" or "all" criteria met in order to be a match. When you include subfolders, Bridge will search any folders that are inside the folder you selected for the Source. This is how you can make a smart collection search multiple folders.

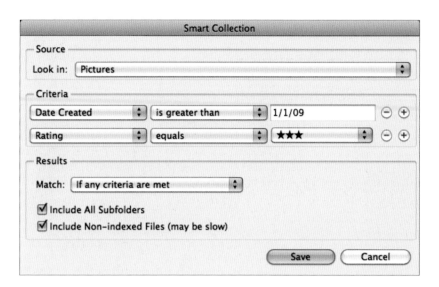

Stacks

Stacks is a helpful organizational and editing feature that allows you to group thumbnails together. Here's how it works:

- In the Collections panel, collections are brown and smart collections are blue.

- To go back and edit the criteria for a smart collection, click Edit Smart Collection at the bottom left of the Collections panel.

- To delete any kind of collection, select the collection and then click the trashcan icon at the bottom right of the Collections panel.

Select multiple thumbnails.

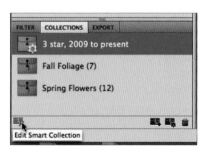

2

Go to Stacks > Group as Stack. This groups the selected photos into a stack. The thumbnails are collapsed into a group, displaying only the first photo in the stack. Imagine the photos are in a pile, so you're looking down on them, and you can see only the top one. The number in the top-left corner tells you how many photos are in the stack. This stack count number is what tells you this is a stack, not a single photo.

3

To expand the stack and see all the photos, click the stack count number (repeat to close the stack).

You can use stacks to group sequences of photos such as portraits or action shots (sports, wildlife). This helps you organize your photos; later you can review the photos in the stack and pick the best one. After selecting the best shot of the sequence, you can delete the rest or simply move your pick to the top of the stack. The first photo in the stack will always be the photo that's displayed when the stack is closed. To change the top photo, you can drag a different photo to

the beginning, or select the photo and go to Stacks>Promote to Top of Stack.

I use stacks to group photos that I've taken for High Dynamic Range (HDR), focus stacking, panoramas, and star trails. For those types of images, I have multiple photos that are combined to create a final image. In the end, all I want to see is the final product, but I still want to keep all the individual photos. By using stacks, I can keep the final image and the pieces together. I make the finished photo the top image; then if I need to see the rest of the photos, I just open the stack.

Initial editing

In Bridge, you can do some initial editing of your photos before you head to Camera Raw to adjust and enhance your photographs. The Filmstrip or Preview workspaces are well suited for editing because they both display a strip of thumbnails along with a large preview of the selected image. You can navigate through the photos in the thumbnail strip using your keyboard's arrow keys. This is a good time to get rid of photos that are clearly not keepers: the accidental photo of your shoe, an out-of-focus shot, or a grossly over- or underexposed image. No need to even open those in Camera Raw or Photoshop. When you find a photo you want to get rid of, you can delete it or reject it.

STACKING TIPS (STACK MUST BE OPEN)

- **Rearrange photos within a stack by dragging and dropping.**
- **Remove a photo from a stack by dragging it out of the stack.**
- **Add photos to a stack by dragging them into the stack.**

See the Stacks menu for additional stack functions and keyboard shortcuts.

If you want even more space for your photos in the Preview and Filmstrip workspaces, you can hide the panels on the left. Press the Tab key to hide the panels and press Tab again to bring them back.

Deleting and rejecting photos

To delete a photo, press Command-Delete (PC: Control-Delete), or click the trashcan icon in the top-right corner of the Bridge window. A message pops up confirming that you want to move the photo to the trash. If you don't want that message to show up every time you delete a photo, click the box next to the *Don't show again* option.

Alternatively, rejecting photos can be used as an intermediate step before actually sending them to the trash. You can reject photos to get them out of the way, review the rejected photos later, and then trash them. To reject a photo,

press Option-Delete (PC: Alt-Delete) or go to Label>Reject. Rejecting gives the photo a Reject label. You can have rejected photos remain visible or set them to disappear as soon as you reject them. If the thumbnail stays visible, it will be labeled Reject in red below the photo.

Hilz_060212_7979.NEF

Adobe Bridge

! Are you sure you want to move "Hilz_051015_6287.NEF" to the Trash?

☐ Don't show again (Cancel) (OK)

To control whether rejects are shown or hidden, go to View>Show Reject Files. If this option is checked, the rejects will stick around; unchecked means the rejects will be hidden immediately. I prefer to have the rejects hidden so that I can focus on the photos I'm keeping.

After you've gone through a set of photos, review your rejects and then delete them. To review your rejects, first make sure you can see them. If they're hidden, go to View>Show Reject Files. Your rejects are likely scattered among the rest of your photos. To just see the rejects, click the Star at the top of the Bridge window to show the Filter menu; then choose Show Rejected Items Only.

If you change your mind about photos, you can remove the Reject designation. Select the photo(s) and then press Command-0 (PC: Control-0), or go to Label>No Rating.

To delete your rejected photos, select them and then press

Command-Delete (PC: Control-Delete), or click the trashcan icon in the top-right corner of the Bridge window.

Ratings and labels

Ratings and labels are two features that can be helpful in the editing process. Ratings add a star ranking to your photos. You can give a photo zero to five stars. How you use ratings is really personal preference. Choose a system that makes sense to you. For instance, you can use stars to rate the quality of the photo: 1 star: okay, 3 stars: good, 5 stars: the best. Or you could use this scale but with one, two, and three stars. You could make it even simpler: 3 stars: it's a keeper, 1 star: you're going to delete it (alternative to using Reject). Give some thought to what would work best for you.

To add a rating, you can go to the Label menu and choose the rating or use the following keyboard shortcut: Command-number (PC: Control-number) to add one to five stars. For example, Command/Control-1, Command/Control-2, and so on. To remove a rating (zero

stars), press Command-zero (PC: Control-zero).

A label is a colored stripe that is displayed under a photo. You can choose from five colors, but a photo can have only one label. Labels are assigned through the Label menu or using a keyboard shortcut. In the bottom half of the Label menu, you can choose from the five labels. In the menu, the labels aren't designated by color but by a name (Select, Second, Approved, Review, To Do). If these default names aren't helpful, you can change them in the Bridge Preferences. Go to Adobe Bridge>Preferences (PC: Edit>Preferences) and then select Labels from the list on the left.

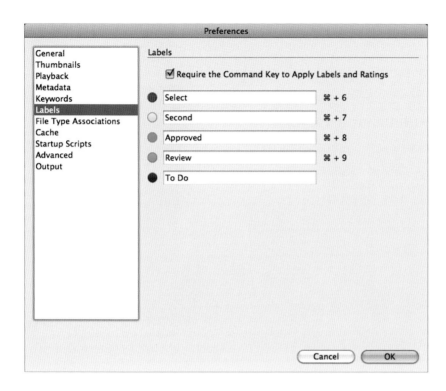

Hilz_051203_7624.NEF

Rotating photos

In Bridge, you can take care of any photos that need to be rotated as well. Sometimes verticals are shown horizontally when imported. To fix the orientation, click one of the curving arrow buttons in the top right of the Bridge window.

Rotate 90° clockwise

In the Label menu, notice that all but the last label has a keyboard shortcut next to it. The fifth label cannot be assigned a keyboard shortcut. For the rest of the labels, you press Command plus 6, 7, 8, or 9 (PC: Control).

Checking focus

Determining which photos are in focus is another important initial editing step. If you have a sequence of similar photos (action series, portraits), it's best to determine now which are the sharpest and spend your time working on those. If a photo is significantly out of focus, that will be readily apparent. But what if it is just a little bit soft? You may not be able to tell from the preview in Bridge. To accurately assess critical sharpness, you should view your photo at 100% (full size). Bridge offers a couple ways to do this.

Loupe

The Loupe is a small square that pops up to show you a piece of your photo at 100%. In the Preview panel, click once on the photo to bring up the Loupe. Click and drag inside the Loupe box to move it around. The Loupe displays whatever the pointed corner of the Loupe is pointing to. To close the Loupe, click once anywhere inside the Loupe square.

The Loupe offers a way to scan around your photo and spot check various areas for sharpness. You can switch to another photo, and the Loupe will stay visible, allowing you to continue to check sharpness through a series of images.

Full-Screen Preview

Another way to check focus is to switch to full-screen mode.

Simply press the space bar, and the selected image will expand to fill the entire screen. Even though the photo is much larger, you're not yet at 100%. Click the photo once, and it will enlarge to 100%. Click and drag the photo to move it around. As compared with the Loupe, this preview allows you to see a larger area. You can even move through your photos using the arrows keys.

Review mode

Review mode offers a full-screen interface for editing your photos along with the ability to access many of the features discussed in this chapter. Begin by selecting the photos you want to review (if you want to review all the photos in a folder, you can just select one photo). Then go to View>Review Mode.

In Review mode there is one photo front and center, with the rest of the selected photos trailing away on the left and right.

Review mode icons

While you're in Review mode, there is a series of icons across the bottom of the screen that offer access to some of the features. Here's what they do when you click on an icon:

- **Left and right arrows:** Use them to move through the photos (you can also use the left and right arrow keys).

- **Down arrow:** Use it to remove the center photo from Review mode (you can also use the down arrow key). The photo is not deleted or rejected, simply deselected. It'll still be in the folder when you exit Review mode.

- **Loupe:** Bring up the Loupe by clicking the Loupe icon, or just click the photo.

- **Collection:** Create a new collection from the displayed photos. After you use the down arrow to remove the ones you don't want, this icon allows you to immediately save your selections into a collection.

- **X:** Click to exit Review mode, or press the Escape key.

With this set of features, the Review mode may seem somewhat basic. In reality, it has a lot more commands available, Just press the H key to see them. As the list shows, you can access quite a number of editing features; they all just have to be accessed using keyboard shortcuts. You can even go directly into Camera Raw from the Review mode. Then when you leave Camera Raw, you'll return to Review mode. If you familiarize yourself with these functions, you'll find you can accomplish a lot in Review mode.

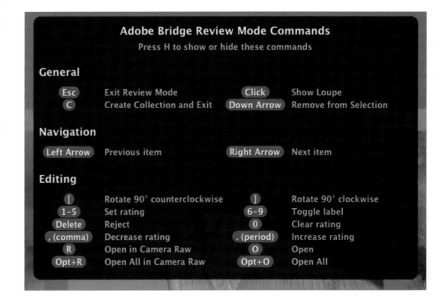

Adobe Bridge Review Mode Commands
Press H to show or hide these commands

General

Esc	Exit Review Mode	Click	Show Loupe
C	Create Collection and Exit	Down Arrow	Remove from Selection

Navigation

Left Arrow	Previous item	Right Arrow	Next item

Editing

[Rotate 90° counterclockwise]	Rotate 90° clockwise
1-5	Set rating	6-9	Toggle label
Delete	Reject	0	Clear rating
, (comma)	Decrease rating	. (period)	Increase rating
R	Open in Camera Raw	O	Open
Opt+R	Open All in Camera Raw	Opt+O	Open All

Conclusion

We've come to the end of the first stage of our digital workflow. You're now familiar with how to organize photos in Bridge, how to import photos, as well as options for initial editing decisions. The next step is to begin making adjustments to individual photos to bring out the best in your images. In the next chapter, we'll look at working in Camera Raw where there are a variety of adjustments for enhancing your photos. They range from changes that affect the entire photo to ones that impact only select areas. There's a lot of power in Camera Raw, and I think you'll be impressed with all you can accomplish.

Chapter 2: Camera Raw: Standard Adjustments

AFTER YOU'VE DONE SOME INITIAL organizing and ranking of your photos, it's time to begin adjusting and enhancing them. The photos from your camera will be in one of two file formats: Raw or JPEG. Raw files have to be adjusted using Camera Raw; we'll get to what that is in a minute. For JPEGs, you could go right to Photoshop to adjust them. However, I recommend using Camera Raw whether you're shooting in a Raw or JPEG format because it's easy to use and offers a lot of flexibility in making adjustments to your photos. We'll go into more detail when we start working in Camera Raw.

So what is Camera Raw? It's an additional piece of software that works within Bridge or Photoshop. It's specifically for adjusting and enhancing your photographs. When you open a photo in Camera Raw, a separate window opens with an extensive set of controls for adjusting your photo. When you're done working in Camera Raw, you close the window and return to Bridge or Photoshop.

To open a photo in Camera Raw, double-click the image thumbnail in Bridge. By default, only Raw files will open in Camera Raw. If you double-click a JPEG, it will open in Photoshop. Let's set up the software so JPEGs will also open in Camera Raw.

Go to Adobe Bridge>Camera Raw Preferences (PC: Edit>Camera Raw Preferences). In the Camera Raw Preferences window, go to the JPEG and TIFF Handling section at the bottom. For JPEG, choose the Automatically open all supported JPEGs option. Then click OK to close the window. Now when you double-click any Raw or JPEG file, it will open in Camera Raw.

JPEG and TIFF Handling

JPEG: Automatically open all supported JPEGs

TIFF: Disable TIFF support

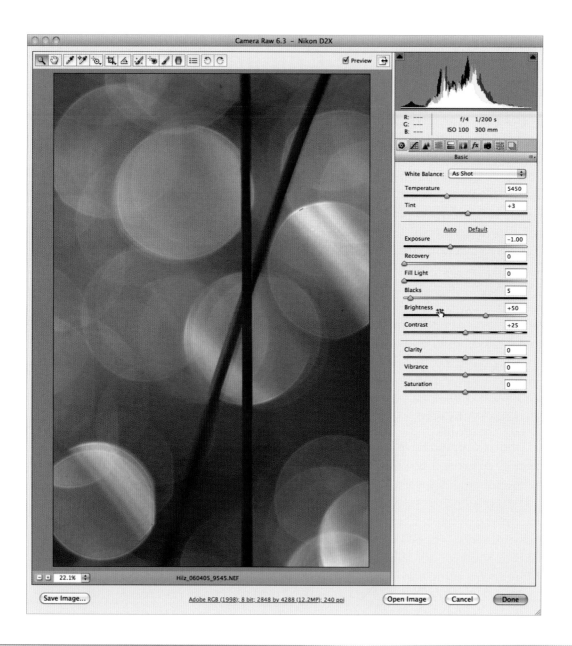

The Camera Raw window has tools across the top of the screen.

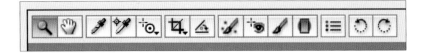

To the right are the image adjustment panels. The Basic panel is the default; you'll see it every time you open Camera Raw. There are tabs for the different panels, ten in all. Most of the adjustments are done using sliders. Some adjustments affect the entire image; others are more specific, such as targeting particular colors.

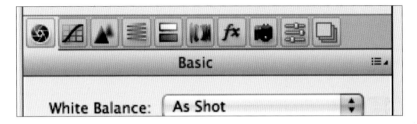

Change to Full-Screen mode by pressing the F key or clicking the Full Screen button in the top right of the window. Press F again or click the button to leave Full-Screen mode.

Basic exposure information (aperture, shutter speed, ISO and focal length) for the selected image is found below the histogram.

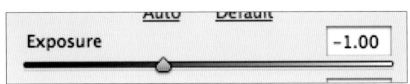

One of the key benefits of using Camera Raw is that you can undo or change an adjustment at a later date without affecting the quality of the image. For example, let's say you drag the Exposure slider to the left to darken an image.

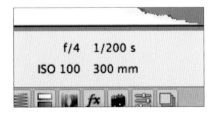

Now go back to Camera Raw and double-click the thumbnail again. Back in Camera Raw the Exposure slider is right where you left it at −1.00. Camera Raw "remembers" the adjustment. This will happen for any adjustment, which means you can always go back and change previous adjustments without affecting the quality of the image.

You then click the Done button to leave Camera Raw. Back in Bridge the image thumbnail has a round symbol next to it that indicates it has been adjusted in Camera Raw.

Opening multiple photos

You can also open multiple photos at one time in Camera Raw. This capability can make for a more efficient workflow.

1

Begin by selecting multiple photos in Bridge.

2 Double-click any of the selected images, and the Camera Raw window will open. Everything will look the same in Camera Raw except there will be a column of thumbnails on the left.

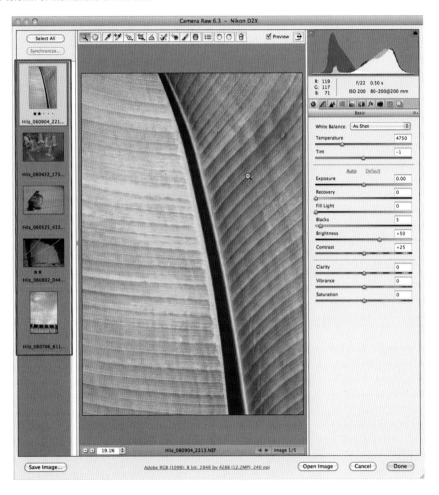

3 Now instead of having to go back to Bridge after each shot, you can adjust all the photos in the column without leaving Camera Raw. Just click on the thumbnail for the photo you want to work on. This capability can save you a lot of jumping back and forth between Bridge and Camera Raw.

Checking focus

1

If you didn't use the Loupe or Full-Screen preview in Bridge to check focus, it's one of the first things to do in Camera Raw. If a photo is significantly out of focus, that will be readily apparent. But what if it is just a little bit soft? You may not be able to tell from the preview in Bridge or the initial viewing size in Camera Raw.

2

To critically assess sharpness, you should view an image at 100%, also called *full size*. In the bottom-left corner of the Camera Raw window is a percentage that is the zoom level. Click the arrows to the right of the percentage and choose 100% from the pop-up menu. The keyboard shortcut to go directly to 100% is Command-Option-zero (PC: Control-Alt-zero).

3 Now you're viewing your photo at full size. You shouldn't choose a percentage larger than 100% because your photo will begin to look blurry even if it's in focus. The photo is now likely enlarged so much that you can't see the entire image.

4 You can use the Hand tool to move the photo around so you can see different parts of it. Select the Hand tool from the toolbar at the top of the Camera Raw window.

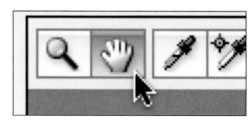

5 Click and drag the photo with the Hand tool to move it around. Move to an area that should be sharp. If it's not sharp, consider whether you want to keep the photo. The image may look good at a small size on a website, but if you try to print it, the lack of sharpness will be readily apparent.

6 When you're done checking the focus, go back to the zoom level percentage and choose Fit in View. This will shrink the image so you can see the entire photo. You can also use the keyboard shortcut Command-zero (PC: Control-zero).

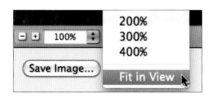

Access the Hand tool without going to the toolbar. Press and hold the space bar, and you'll switch to the Hand tool. Continue holding down the space bar while you use the Hand tool. When you're done, release the space bar.

Crop tool

Are there distracting elements around the edges of the photo? Did you include more than you wanted to in the composition? Will cropping result in a better image? These are a few reasons to crop a photo.

When you crop in Camera Raw, you are not actually getting rid of the rest of the photo. Camera Raw is simply making a note about which part of the photo you want to display. Just as described with the Exposure adjustment earlier, cropping can always be changed later. You can come back in a week or a month and change the crop or remove it entirely.

Remember that the more you crop, the less information (pixels) you end up with in your final photo. Cropping away a large amount of your photo can limit the print size you can produce.

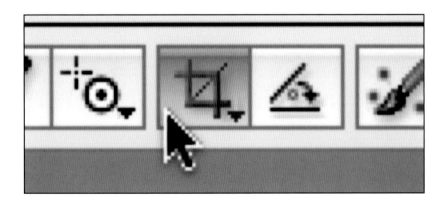

1

Select the Crop tool from the toolbar.

2

Click and drag on your image to draw a crop box. Don't worry about getting the crop box just right because you can easily fine-tune it.

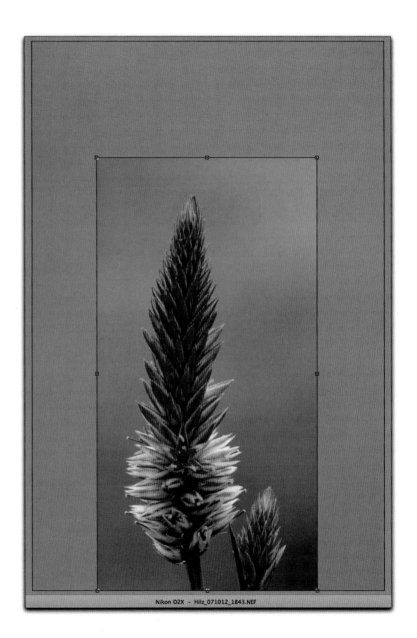

Nikon D2X – Hilz_071012_1843.NEF

ADJUSTING THE CROP BOX

- To change the size of the crop, move the Crop tool to an edge or corner of the crop box. When the Crop tool switches to a double arrow, click and drag to resize the box.

- To move the entire crop box (and not change the shape), click and drag inside the box.

- Rotate the box by placing the Crop tool outside the box (the tool changes to a curved double arrow); then click and drag.

CROP TOOL TIPS

- When rotating the crop box, hold the Shift key to rotate in set increments (this makes it easy to rotate 45 or 90 degrees).

- When clicking on the corners to resize, hold Shift to keep the resizing proportional.

- When you have the crop the way you want it, press the Return/Enter key to apply the crop.

- To remove a crop, click and hold on the Crop tool in the toolbar; then choose Clear Crop from the drop-down menu. You can also press the Delete/Backspace key when the Crop tool is selected.

Proportional cropping

Want to crop your photo but keep the original proportions so it doesn't look like you cropped it? Here's how:

1. Click and drag with the Crop tool from the top-left corner to the bottom-right corner. You're drawing the crop box to include the entire photo, so nothing is excluded yet.

2. Place the Crop tool on one of the corners of the crop box, press and hold the Shift key, and then drag to resize the box. Your crop now maintains the proportions of the original photo. You can still click and drag inside the box to change its position. Just remember to hold the Shift key whenever you resize the box.

For the proportional cropping options, 1 to 1 gives you a square crop, 2 to 3 is the proportion for a 4×6-inch photo, and 4 to 5 is the proportion for an 8×10-inch photo.

Normal

1 to 1
2 to 3
3 to 4
✓ 4 to 5
5 to 7
9 to 16

Custom...

✓ Constrain to Image

Show Overlay

Clear Crop

The drop-down menu for the Crop tool offers preset crop proportions (click and hold on the Crop tool in the toolbar). These options can be useful if you want to make sure your cropped image fits a particular proportion.

Straighten tool

If your picture is tilted to the left or right, you can use the Straighten tool to fix it.

Correcting a photo with a slanted horizon line is a common use for this tool.

 Select the Straighten tool in the toolbar. You will draw a line along the horizon or other horizontal line you want to be level.

213.5%

JPEG – Straighten.jpg

2

Using the Straighten tool, click and drag from one end of the horizon, drawing a line across the photo, but don't release the mouse button. Also, don't worry about having the line match the horizon exactly.

After you've drawn the line across the photo, match it up with the horizon by moving your mouse up or down. When it's aligned with the horizon, let go of the mouse button.

When Camera Raw straightens a photo, it looks a bit strange. The photo looks askew with parts of it cut off. To complete the process and make the straightened photo look normal, press the Return/Enter key.

What is straightening doing?

The straightening process is actually a combination of rotating and cropping. After you do the straightening, what shows up around the photo is a crop box. The gray area surrounding the photo shows you what will be cropped to achieve the straightening. Notice that in the crooked horizon example, the top and bottom of the crop box are parallel to the horizon, which tells us the straightening has occurred.

To undo straightening, select the Crop tool and then press the Delete key.

You always lose part of your photo when you straighten. The more you have to straighten, the more of the photo you will lose around the edges.

Spot Removal tool

The Spot Removal tool is incredibly useful. It brings the basic capabilities of Photoshop's Spot Healing Brush and Clone Stamp tools to Camera Raw. The Spot Removal tool is not for extensive cloning tasks (as the name suggests), but for small, quick fixes. It's great for removing the spots caused by a dirty sensor. No matter how careful you are about changing lenses, eventually you'll start seeing small dark spots on your photos. This tool saves you from having to go into Photoshop just to remove a dust spot in the middle of your blue sky. You can also use the tool to remove skin blemishes.

1 Zoom in to 100% (use the zoom level box in the bottom left) to make the spots you want to remove easier to see. Or use the keyboard shortcut Command-Option-zero (PC: Control-Alt-zero).

Select the Spot Removal tool in the toolbar. You should use the Hand tool to move around to the different areas of the photo you want to retouch. The space bar gives you quick access to the Hand tool. Hold down the space bar; then click and drag to move the photo around. Let go of the space bar to return to the Spot Removal tool.

Choose Heal from the drop-down menu in the Spot Removal panel on the right side of the window.

Click and drag at the center of the spot you want to remove. This allows you to draw a circle around the spot. Create a circle that is about the same size (or slightly larger) as what you're trying to eliminate. When you release the mouse button, the spot disappears. In many cases that's all you'll need to do. Each circle on the image represents a place that was retouched.

To view the retouched image without the circles, uncheck the Show Overlay box at the bottom of the Spot Removal panel.

Spot removal tips

- You'll see two circles when you use the Spot Removal tool. The red circle is the retouched area. The green circle is the source—the area that Camera Raw samples from to fix the area in the red circle.

- If the red circle didn't get placed over the spot correctly, you can move it by clicking and dragging inside the circle.

- If the Spot Removal tool didn't fix the area in the red circle, the reason may be that it didn't sample the correct area. Click and drag the green circle to change the sample area.

- If you just click (not drag) on a new spot, you'll get a circle that's the same size as the last circle you created. This tip is useful if you want to remove multiple spots that are the same size.

- To select a previous spot, click on it.

- To remove a previous spot, click on it and then press the Delete key.

- To undo all retouched areas, click the Clear All button at the bottom of the Spot Removal panel.

Red-Eye Removal tool

Red eye in people (caused by the flash) is an annoying distraction in our photographs. Fortunately, the Red-Eye Removal tool makes it easy to eliminate.

1

Select the Red-Eye Removal tool in the toolbar. Depending on how large the eyes are in the photo, you may want to zoom in to 100% to be able to see them more easily.

2

Draw a large box around the eye; the box should be a bit larger than the eye. Camera Raw will detect where the eye is within the box and select part of the eye.

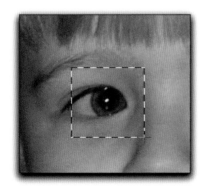
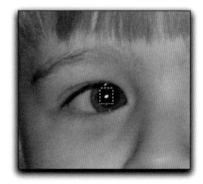

After you draw the box, Camera Raw automatically removes the red eye. Repeat as necessary with other eyes. Camera Raw will leave a box around each adjusted eye.

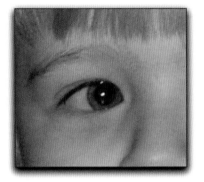 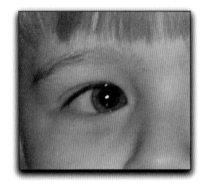

If the darkness or size of the pupil is not right, use the sliders in the Red-Eye Removal panel on the right. You can see the real-time effect as you move the sliders. This makes it easy to tweak the appearance of the eyes.

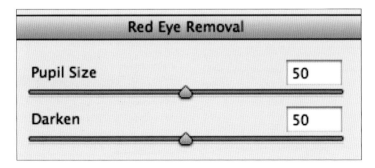

Red-Eye box is too small

The redder the eyes are, the better the Red-Eye Removal tool works. If the red is faint or muted, the tool may not detect the whole eye. In these situations you may get a very small box over just part of the eye. However, all is not lost; you just need to take a few extra steps:

1. Zoom in so you can easily see the little box.

2. Position the Red-Eye Removal tool over one of the sides of the box.

3. When the cursor changes to a double arrow, click and drag to change the size of the box.

4. Repeat with the other sides until the box includes the whole eye.

5. Adjust the sliders for pupil size and darken as described previously.

- To select an adjusted eye, click on the box over it. The selected box will have a red and white dotted outline.

- To see the results without the boxes on the eyes, uncheck the Show Overlay box at the bottom of the Red-Eye Removal panel.

- To undo all the adjusted eyes, click the Clear All button at the bottom of the Red-Eye Removal panel.

Basic panel

After you've taken care of the "cosmetic" issues with cropping, straightening, spot removal, and red-eye removal, it's time to turn to the adjustments in the Basic panel. This is the place to begin adjusting the tone and color of your photograph. As the name suggests, this panel has the basic adjustments you'll want to use. The other panels are more specialized in their function. Start with the White Balance adjustment at the top of the panel and then work your way down through the rest.

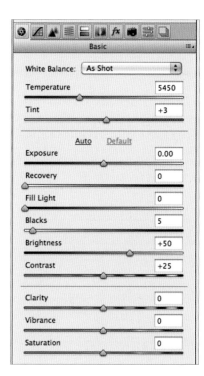

White Balance

The White Balance sliders allow you to change the color temperature of an image. This could be necessary because the wrong white balance was selected when the photo was taken, or you want to change it for creative effect.

By default, the white balance is set to As Shot, which means it will match the white balance setting used by the camera when the picture was taken.

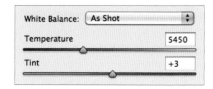

To choose a white balance preset, click on As Shot and choose a setting. These are the same white balance settings you have available in-camera.

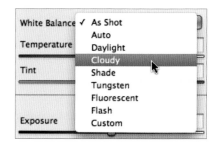

For full control over the white balance, you can adjust the sliders yourself. If you're trying to achieve a neutral image, then you should adjust both sliders to remove unwanted color casts. The Temperature slider is the primary adjustment; it makes the photo warmer or cooler. The Tint slider is a fine-tuning adjustment. It adds magenta if you drag to the right or green if you drag to the left. You should use Tint to fix a green or magenta color cast. For example, if a photo is too green, drag the slider to the right to add magenta, which balances out the green. Do the opposite if the photo is too magenta.

Cooler version

Warmer version

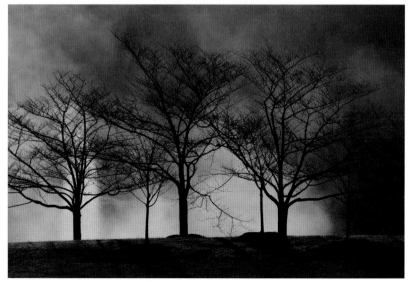

Exposure

Take a look at your picture as a whole. Is it too light? Too dark? Just right? Use your eyes first to decide whether it would help to increase or decrease the exposure. The Exposure slider affects all tones: highlights, light tones, midtones, dark tones, and shadows. Camera Raw also offers visual aids to help you know if you should increase or decrease exposure.

Histogram

When evaluating the exposure, you should avoid having a histogram that is losing information in the highlights or shadows (called *clipping*). This is shown by the lack of a gap at either end of the histogram.

When there is no gap, you'll see one or more colors flush against the left or right side of the histogram. Visualize two walls going up at either end of the histogram. When the histogram hits these walls, it goes flat and climbs the wall. That's when you're losing highlight and/or shadow detail.

A histogram without a gap on the right tells you some detail has been lost in the highlights (brightest areas of the image).

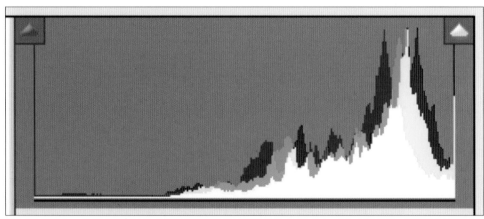

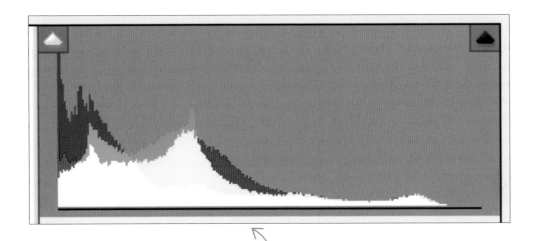

A histogram without gap on the left tells you some detail has been lost in the shadows (darkest areas of the image).

Exposure warnings

The histogram offers some useful information, but it doesn't tell you which areas of your photo have lost highlight or shadow detail. To turn on an overlay that marks the under- and overexposed areas, click the triangles in the top-left and -right corners of the histogram box. The triangles are "on" when there is a white box around them. Click the triangles again to turn off the warnings.

Overexposed areas (losing detail in highlights) are marked with red.

Underexposed areas (losing detail in shadows) are marked with blue.

Not all images will show the red or blue warnings (double-check you've clicked the triangles!). And that's a good thing. No warnings means the entire range of tonalities (shadows to highlights) was captured in your exposure.

If you move the Exposure slider (especially to the extremes), you'll see the amount of red and blue increase or decrease. Adjust the Exposure slider to achieve the best overall exposure. This means don't severely darken the photo just to get rid of all the red areas, and don't overly lighten to remove all the blue. Aim for a balance, which may mean you still have some of those red and/or blue warnings. No worries about any lingering warnings; we'll take care of them when we get to the Recovery and Fill Light sliders.

Blacks

Most photos benefit from having the darkest tone in the picture close to black. After making any adjustments to the Exposure slider, I set my black point. This is similar to moving the Black slider in the Levels section in Photoshop. The default setting for Blacks is 5.

Here are a couple of considerations before moving the Blacks slider:

- Has the shadow warning marked any areas of the photo in blue? If so, you either should leave the slider alone or move it to the left to try to reduce the blue areas. If you move the Blacks slider to the right, the area of blue will increase, meaning more of your photo is pure black. This can be done for creative effect, but generally you don't want a lot of your photo to be pure black.

- If there aren't any shadow warnings, how do the darkest areas look to your eye? Do they look overly dark and heavy? If this is the case, try moving the slider to the left. It goes down only to 1, so move it slowly to see how the shadows change.

- If neither one of the preceding situations applies, then move the slider to the right.

1

An image that doesn't have any shadow warnings will usually benefit from increasing the Blacks amount. Hold down the Option (PC: Alt) key while moving the Blacks slider. Your photo will turn white; this is a visual aid to determine how much to move the slider.

2

Move the slider until you see some color(s) start to appear. You don't have to stop at the first sign of color, but stop when there's a scattering of color. The best place is likely between the first signs of color and the first blacks.

Release the Option (PC: Alt) key to see what your photo looks like. The dark tones of your image should now look richer.

Recovery and Fill Light

The Recovery and Fill Light sliders allow you to increase the dynamic range of your photographs. You can use them to bring out more detail in the brightest and darkest areas. As with all adjustments, you'll have the best results by starting with a good exposure. You can then go on to make the image look even better.

The Recovery slider will bring back a certain amount of detail in areas where highlight information is clipped (areas that the highlight warning turns red). If areas in the initial exposure are pure white because they have lost all detail, Camera Raw can't bring back detail because there wasn't any there to begin with.

After moving the Exposure slider to obtain the best overall exposure, see whether the highlight warning turns any areas red. If so, move the Recovery slider until the red is gone. Generally, you should remove all red warning areas and then further adjust to your liking. If you continue to move the slider to the right, it will progressively darken more light tones. This isn't necessarily a bad thing. You may have a photo in which the light tones are not overexposed, but they are too bright. You can use the Recovery slider to take them down a little.

Clipped highlight details are marked by the red areas

Nikon D2X – Hilz_070721_2017.NEF

37.1%

The Fill Light slider works at the other end of the scale. It brightens the shadow areas of your photo. If you have clipped shadows (marked by blue), move the slider over until they're gone, or at least reduced. The further you move the slider, the more dark areas it will lighten. When you have a photo with high contrast, being able to lighten those heavy shadows is a welcome capability.

Recovery slider adjusted to bring back detail in the highlights

Clipped shadow details are marked by the blue areas

Fill Light slider adjusted to lighten shadows

Brightness

The Brightness slider also lightens or darkens a photo, but it mostly affects the midtones. It does not significantly affect the highlight and shadow areas. As a result, Brightness adjustments won't clip detail in the shadows or highlights. The Brightness amount always begins at +50. When you brighten a photo, be careful not to go too far; otherwise, the image can end up becoming washed out. Alternatively, if your photo started out a little washed out, or "flat," try reducing the brightness a small amount (+30 to 40); this change can make the midtones richer.

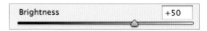

Nikon D2X - Hilz_070712_0596.NEF

Nikon D2X - Hilz_070712_0596.NEF

Original photo, colors washed out

Brightness reduced

Contrast

Contrast can be used to add more "punch" to your images. Raw files in particular often look flat and dull initially and will definitely benefit from a Contrast increase. Look to use a small to moderate increase, such as +40 to 50. Of course, the amount you change depends on the image, but going too high can create an unnatural appearance.

Contrast	+25

Nature photography subjects such as landscapes and flowers can use higher amounts of contrast than photographs of people.

Original photo, dull appearance

Contrast increased, tones are improved

37.1% Nikon D2X · Hilz_070719_1758.NEF

Clarity

Clarity is a localized version of contrast. It adds contrast and sharpening to the details of your photo. Increasing the Clarity setting (default is zero) can help fine details pop, as well as emphasize texture. In the following photos, notice that when the Clarity is increased, the detail in the door is more apparent. By comparison, the original photo looks a bit flat.

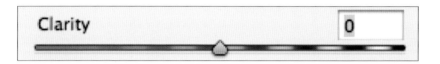

Original photo, no Clarity added

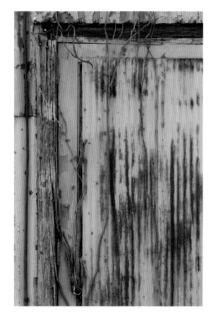

Clarity increased to +100

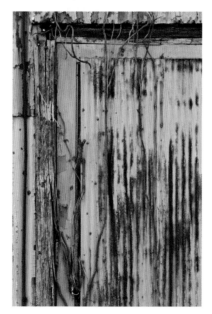

Decrease Clarity (negative number) to purposely soften an image. Can be an attractive effect with portraits.

Saturation

Saturation controls the intensity of the colors in your images. This is another setting where a little goes a long way. Don't overdo the Saturation if you want your photos to look natural—especially for people. Vibrance is a better adjustment for photos of people; we'll look at that setting next.

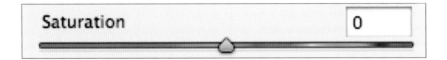

Saturation 0

Original photo, no Saturation added

Saturation increased to +20

Vibrance

The Vibrance control is a great compliment to Saturation. It's subtler than adding Saturation because it does not intensify all colors equally. If a color is already very intense (a sunset for instance) Vibrance will not further increase the intensity. It's also a good choice when you have people in your pictures because Vibrance does not increase the intensity of skin tones. This series of photos illustrates which colors Vibrance does and does **not** affect.

Vibrance 0

1

This image has no Vibrance added (and no saturation).

2

Vibrance has been increased. Notice that the color of shirt and background are more intense, but the skin tones still look great.

3

To really see what Vibrance is (or isn't) doing, move the slider all the way to the left (−100). All the colors except for the skin tones are desaturated. Desaturating using Vibrance can also be a creative control.

Conclusion

We've come to the end of the adjustments in the Basic panel. For many photos, changing these settings may be all you need to do because there is such a variety of adjustments in this panel. In the next chapter, we'll look at some of the other panels that allow you to make more targeted or selective adjustments to your photos.

Chapter 3: Camera Raw: Advanced Adjustments

IF YOU'VE WORKED WITH THE settings in the Basic panel and you're looking for even greater control when adjusting your photographs, there some other panels and tools in Camera Raw you'll find useful. In this chapter we'll look at the following panels: Tone Curve, HSL/Grayscale, and Lens Corrections. Plus, we'll look at two more tools: the Adjustment Brush and Graduated Filter.

To switch between panels, go to the row of icons above the Basic panel and click the icon for the panel you want to use.

Basic

Tone Curve

Tone Curve is the second panel in the Camera Raw window. It can be used to lighten or darken a certain range of tones, such as light or dark tones. The name *tone curve* may seem a misnomer because there is initially no curve to be seen, just a diagonal line. What happens is the line bends when you move the Tone Curve sliders.

There are two tabs at the top of the Tone Curve panel: Parametric and Point. These tabs offer different ways of adjusting the curve. Parametric uses sliders, and Point requires you to add points to the curve manually. We'll focus on the Parametric adjustments here.

To adjust the tone curve, use one (or more) of the four sliders below the curve. The slider names tell you what range of tones they affect. Feel free to experiment here to get an idea for which tonal adjustments you want to make. You can always set a slider back to zero if you don't like what it changes in your photo.

In the following example, I moved the Lights slider to the left, darkening the light tones. In the photo the light tones are primarily the background, so the adjustment had very little effect on the bird. However, this change did make the feathers a little dull, so I increased the Highlights slider.

Using the sliders makes it easy to work with the tone curve. You don't really have to pay attention to what the curve is doing. Just move the sliders, and Camera Raw takes care of bending the curve. You can focus on how the photo looks.

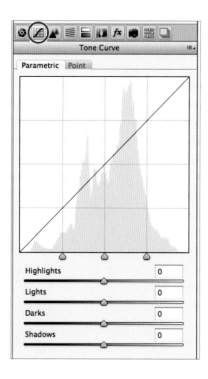

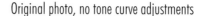

Original photo, no tone curve adjustments

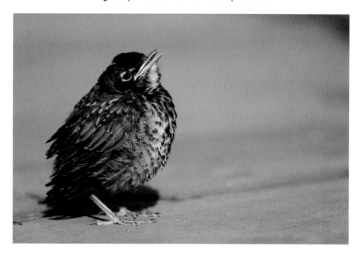

Adjusted photo with Highlights and Lights sliders moved

Tone Curve + Targeted Adjustment tool

There's even a way to make adjusting the tone curve easier, and that's using the Targeted Adjustment tool. You'll find this tool in the toolbar. Click and hold on the tool icon and choose Parametric Curve from the pop-up menu.

2

Using the Targeted Adjustment tool, you don't even have to think about sliders because you work directly on your photo. Move the tool to an area of the image you want to lighten or darken. Then click and drag to lighten or darken that tone. You can choose to drag up and down, or left and right; they have the same effect.

3

If you watch the tone curve as you do this, you'll see Camera Raw is automatically moving the matching slider. As you use this tool, remember that the tone you click on is being adjusted throughout the photo, not just where you click. For instance, if you click and drag on a light tone, the adjustment will affect all the light tones in the image, not just the area where you clicked.

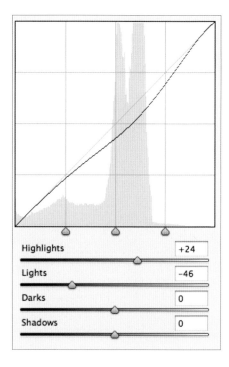

HSL/Grayscale

HSL/Grayscale is the fourth panel, and it has a lot of adjustments packed into it. HSL stands for Hue, Saturation, Luminance. Click on the tabs across the top of the panel to access the settings for each adjustment. Each tab has a list of eight colors, allowing you to target what colors in the photo your adjustment will affect. You can make adjustments in all three tabs for any photo. Grayscale refers to converting to black and white, another option in this panel.

Hue

Hue adjustments will change the actual colors in your photo. How the colors will shift is indicated by the color range shown on the sliders. For instance, the Yellows slider transitions from orange to yellow to green. This means that if you move the Yellows slider to the left, things that are yellow will turn to orange; if you move the slider to the right, they will shift to green.

You can use the Hue adjustment for creative effect as well as to fix an unwanted color shift for a particular color.

Saturation

As described in the "Saturation" section for the Basic panel in Chapter 2, saturation changes the intensity of the colors. Adjusting saturation in the HSL panel gives you more control than the overall Saturation slider because you can choose which color you want to saturate or desaturate. Perhaps the reds and oranges in your photos are already intense enough, but you'd like the greens to be punched up a bit. All you need to do is move the Greens slider in the Saturation tab, and you'll be targeting the color you want to adjust.

Luminance

Luminance is the brightness of a color. Move a slider to the right to lighten that color; move it to the left to darken the color. If you have a blue sky that's too light, move the Blues slider to the left to darken it, and you'll have a richer blue sky.

Targeted Adjustment tool for HSL

You can also use the Targeted Adjustment tool, introduced previously in the "Tone Curve" section, with the HSL adjustments. In the toolbar, click and hold on the tool icon and choose Hue, Saturation, or Luminance from the pop-up menu.

Then click and drag on the color you want to change in the photo. Camera Raw detects what color you clicked on and moves the appropriate sliders. A convenient feature of the Targeted Adjustment tool is that it can make multiple sliders move for a more accurate adjustment. For example, a blue sky is not always a true blue; it may be a mixture of blue and aqua. The Targeted Adjustment tool will recognize this and move both the Blues and Aquas sliders. Pretty smart!

Convert to Grayscale

To make a black-and-white conversion, check the Convert to Grayscale box at the top of the HSL panel. The three tabs go away, and a new Grayscale Mix tab appears. It has the same list of colors, but they are used for adjusting the shades of gray. You'll notice that the sliders are not all set to zero. The reason is that, by default, Camera Raw adjusts the sliders to produce a good black-and-white conversion. Think of this as a starting point because you have full control to further adjust the sliders.

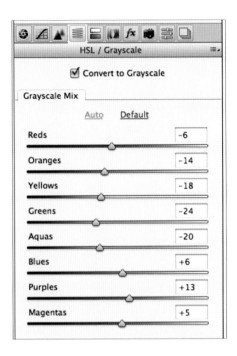

If you'd prefer to have all the sliders reset to zero, click Default at the top of the panel.

Why are we working with color sliders on a black-and-white image? Well, even though the image is grayscale, Camera Raw still "remembers" the colors of the original image. How the color sliders affect a black-and-white image depends on the color version of the photo. The sliders are for lightening and darkening. If there were green grass in the photo, moving the Greens slider

to the left would darken the grass. The same would be true with the Blues slider and a blue sky. There isn't a recipe for where all the sliders should be set to create a good black-and-white photograph. The right settings depend on the original image. Experimentation is the key, and the more you work with these sliders, the better idea you'll have of how to go about adjusting the various colors.

Targeted Adjustment tool for grayscale

Because it may be difficult to remember exactly what color everything was in the color version of an image, the Targeted Adjustment tool comes in very handy when you're working in black and white.

Parametric Curve	⌥⇧⌘T	
Hue	⌥⇧⌘H	
Saturation	⌥⇧⌘S	
Luminance	⌥⇧⌘L	
✓ Grayscale Mix	⌥⇧⌘G	

1 From the Target Adjustment tool menu in the toolbar, choose Grayscale Mix. This tool is used the same way for black and white as it is for HSL.

2

Starting with the Auto Grayscale Mix, click on the part of the photo you want to change; then drag up/down or left/right to lighten or darken. Camera Raw determines what color you clicked on and moves the matching slider(s).

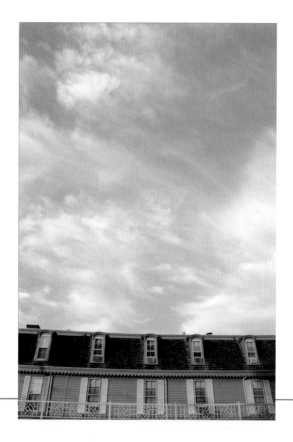

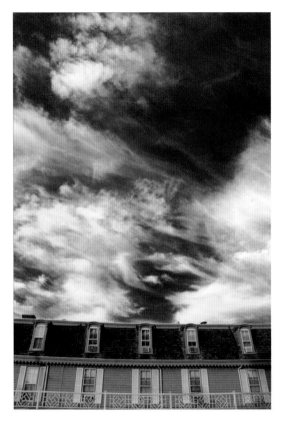

With the Targeted Adjustment tool, I clicked on sky in the top right and dragged down to darken the sky, making the clouds stand out. Camera Raw moved the Blues and Aquas sliders for me.

Adjustment Brush

Although the Tone Curve and HSL/Grayscale panels offer ways to target particular tones and colors, they can't match what the Adjustment Brush offers. Let's say you have a photo that includes a blue house and a blue sky. You want to make the house lighter. If you use the HSL/Grayscale panel to lighten the blues, it will affect both the house and the sky. With the Adjustment Brush, you can get the results you want because you're able to selectively apply various adjustments. Here's another example: There are two orange flowers in a photo, and you want to increase the saturation of one of the flowers. Using the Adjustment Brush is the only way you can increase the saturation of just one of the flowers.

1 To start using the Adjustment Brush, select it in the toolbar. The Adjustment Brush settings then show up in the panel area.

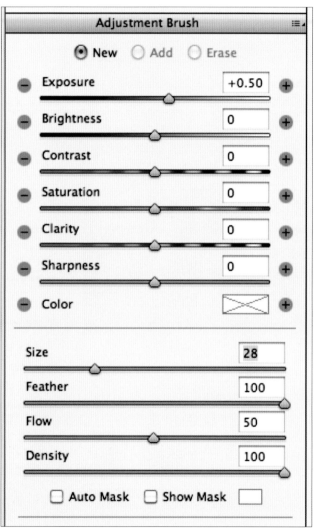

You begin with the New button selected at the top when you're using the brush for the first time. After you've used the brush, you will be able to select the Add and Erase buttons. The Adjustment Brush has seven adjustments you can apply with it. One or more adjustments can be used at a time. To use the brush, you set the adjustment by moving one or more of the sliders and then "brush on" the adjustment by clicking and dragging on the photo.

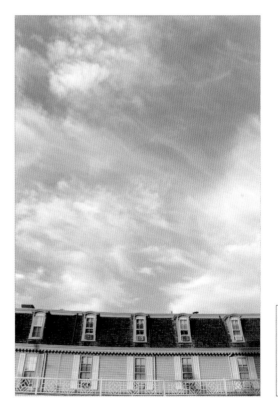

Let's run through basic use of the brush. For this photo I want to darken the sky and the lower set of windows. I don't want to affect the upper windows or the roof. I begin by setting the Exposure to −1.00.

The brush is represented by a circle. You click and drag the circle over the parts of the image where you want to apply the adjustment. In my photo I selectively applied the darkening by brushing over the sky and lower windows.

Brush settings

For finer control when using the Adjustment Brush, you may want to be familiar with the brush settings.

Size: Choose a brush size based on the area of your photo that you want to work on. Small area, small brush. Large area, large brush. You can change the size of the brush while you're working. In the photo I just worked on, I used a large brush for the sky and a smaller brush for the windows.

Feather: A larger feather amount gives the brush a softer edge. I prefer a softer brush (50–100) because it makes it easier to blend in adjustments with surrounding areas and not have the adjustments look stamped on.

Flow: Using a Flow amount less than 100 allows you to gradually brush in the adjustment. Each time you move the brush over the same area, it applies a portion of the full adjustment. The more you go back and forth over the same area, the more of the adjustment is applied, eventually up to the full amount. The lower the Flow amount, the more gradual the application. This can be a good setting to use when you want to apply varying amounts of the adjustment to different parts of the photo. This saves you from having to use multiple brushes.

Density: Using a Density lower than 100 limits you from applying the full adjustment with the brush. It's similar to Flow in that you're applying a portion of the full adjustment. However, unlike using Flow, going back and forth over the same area doesn't increase the amount of the adjustment applied. The brush puts down a fixed portion amount of the adjustment and that's it.

☐ **Auto Mask** ☐ **Show Mask** ☐

Auto Mask

Auto Mask is a helpful feature
if you're brushing near an edge
that you don't want to go past
with the brush, such as a tree
line or a roof. If you check the
box, the brush will try to detect
where these edges are and avoid
applying the adjustment past
the edge.

Show Mask

Check the box for Show Mask
to turn on a color overlay that
shows where you have applied
adjustments with the selected
brush. I find it very useful to be
able to see exactly where I did, or
did not, brush on the adjustment.
You can still use the brush and
the eraser while the mask is
visible. To change the color of the
mask, click the color rectangle
next to Show Mask. The Color
Picker window appears, and you
can click on the new color you
want to use. I prefer red at a low
opacity.

Here is the mask for the photo I worked on earlier. The red overlay (mask) shows up everywhere I used the brush.

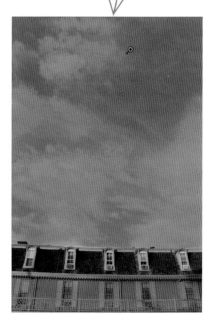

- If you make a mistake with the brush, click the Erase button at the top of the panel. Your brush turns into an eraser; then you can click and drag on the photo where you want to remove the unwanted adjustment.

- To use a brush with different adjustments, click the New button at the top of the panel. Then choose your adjustment settings and brush them on your photo.

- Each brush is represented by a "pin" on the photo (a small solid-gray circle). To go back and use a previous brush, click its pin. This will switch the adjustment settings to those for the selected brush.

- If you use a lot of different brushes and their pins are cluttering up your photo, uncheck the box for Show Pins at the bottom of the panel.

- To delete all the adjustments a particular brush has made to your photo, click on its pin and then press the Delete key.

Graduated Filter

The Graduated Filter is similar to using a graduated neutral density filter with your camera, but with many more options. This filter is particularly helpful when you want to enhance a sky. You can easily apply the effect to most of the sky and then have a transition area where the sky meets the land so that the adjustment blends seamlessly with the rest of the photo. The settings are much the same as those for the Adjustment Brush.

To started using the Graduated Filter, select it in the toolbar. The Graduated Filter settings show up in the panel area.

I'm going to use the same clouds and building photo I worked on with the Adjustment Brush, but I'll go back to the original version. I'm going to use the Graduated Filter to darken the sky, so I begin by setting the Exposure to −1.00. To apply the Graduated Filter to the photo, click and drag down the image, drawing a vertical line. Don't worry about drawing the line in exactly the right spot because you can easily fine-tune the filter's position later.

GRADUATED FILTER TIPS

- To use a second Graduated Filter, click the New button at the top of the panel. Then set the adjustments and draw a new Graduated Filter.

- Each filter is represented by two circles connected with a dotted line. To go back and work with a previous filter, click on either of the circles. This will switch the adjustment settings to those for the selected filter.

- To hide the lines of the Graduated Filters (but still show the effects), uncheck the box for Show Overlay at the bottom of the panel.

- To delete a Graduated Filter, click on one of its circles and then press the Delete key.

There are horizontal lines at either end of the vertical line. One line is green; the other, red. The colors are important because they tell you how the adjustment is being applied to different parts of the photo. Above the green line, the full effect is being applied (in this case a −1.00 Exposure adjustment). Below the red line, none of the effect is being applied. In between the horizontal lines is a transition area where the effect gradually shifts from full effect to no effect. In the photo, the top three-fourths of the sky is being full darkened. In the bottom one-fourth of the sky, the darkening effect is gradually fading to nothing.

Adjusting the Graduated Filter

- Adjust the space between the horizontal lines: Click and drag the red or green circle to expand or shrink the space (transition area). A larger space will create a more gradual transition; a smaller space means a more abrupt transition.

- Move the filter: Click and drag the vertical line, and the entire filter will move. The space between the top and bottom lines stays the same.

- Rotate the filter: Click and drag the red or green line (not the circles), and the filter will rotate. Changing the orientation of the filter changes how it affects the image. Rotate it 90 degrees, and the effect will spread across the image instead of up and down. Rotating the filter upside down will flip its effect: The bottom of the photo will be affected but not the top.

- Hold down the Shift key while rotating to turn the filter in defined increments.

- Take care to click directly on the line/circle of the filter; otherwise, you may end up creating a new Graduated Filter. If that happens, just press the Delete key to remove the unwanted filter.

Lens Corrections

Lens Corrections is the sixth panel and has fixes for problems caused by lenses, including distortion, chromatic aberration, and vignetting. As with the Straighten, Spot Removal, and Red-Eye Removal tools, the Lens Corrections settings are for fixing problems as opposed to creative effect. The Lens Corrections panel is available only in Camera Raw for Photoshop CS5 and later. If you are working with a previous version of Camera Raw, you'll find these same adjustments within Photoshop (see Chapter 5 for more information).

There are two tabs at the top of the panel: Profile and Manual. In the Profile tab, if you check the box for Enable Lens Profile Corrections, Camera Raw will try to find the lens you used in a database that enables it to automatically apply corrections.

In the Manual tab, you can make all the corrections yourself. I'll go through the Manual settings because those adjustments are available to all lenses. Each of the sliders is a fix for a specific problem. So you don't need to move a slider if you're not having that problem. I'll describe what each slider fixes, but a great way to see for yourself (even if

Press the V key to turn on gridlines (press again to turn them off). Use them to help you determine when vertical and/or horizontal lines are straight.

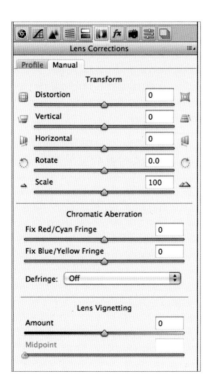

your photo doesn't need it) is to move a slider from one end of the scale to the other and watch what happens.

Distortion, Rotate, Scale

Distortion: This adjustment provides a fix for two types of distortion called *pincushion* and *barrel*. They can result in a slightly bulging or collapsing look to the center of the image. More likely to occur with wide angle lenses.

Rotate: The rotate adjustment is for straightening a crooked photo, an alternative to using the Straighten tool.

Scale: Often when you make any of the preceding adjustments, your photo will end up with some of the corners and sides being curved or slanted. Drag the Scale adjustment to the right to "expand" the photo until those unwanted edges disappear. As a result, you'll lose some of your photo, but there's no way around it with these corrections.

Vertical and Horizontal correction

The Vertical and Horizontal corrections are most often needed with architectural photography. If the camera is not

pointed straight at a building, there is often some amount of distortion. If the camera is tilted up or down, the sides of the building will be slanting in or out to some degree. If you turn the camera left or right to shoot down the length of a building, the top and bottom of the building will be slanted. Sometimes these distortions can be used as a creative effect, but when they're not, you can use these corrections to fix them.

Tilting the camera up when I took this picture created perspective distortion. The building looks as if it's leaning backward and the sides aren't straight. This effect is called *keystoning*. I'll use the Vertical correction to fix the problem.

	Distortion	0	
	Vertical	-46	
	Horizontal	0	

2 I moved the Vertical slider to the right until the building was standing upright. You can see the building is straight, but sides of the image aren't. This is the cost of fixing distortion: The sides of the photo become bent or slanted. To get back to a photo with straight edges, you'll need to use the Scale adjustment or the Crop tool.

When you're taking a photo, compose a little wider than necessary if you know you'll have to correct distortion later. That way, when you fix the distortion and lose some around the edges, you won't lose important parts of your photo.

Chromatic aberration

Chromatic aberration is a colored line that appears along a high-contrast edge, which is where a dark tone meets a much lighter tone. This line, also called *fringing*, will either be red, blue, or yellow. Whatever color of the fringing, that's the color slider you should move. For example, if the fringing is blue, then move the slider for Fix Blue/Yellow Fringe. Drag the slider until the fringing disappears.

Chromatic aberration may not be apparent when you're looking at the entire photo. Zoom in to 100% when looking for, and correcting, the fringing.

 Here's a photo of a backlit leaf and seed pod. The backlighting was so intense that everything became a silhouette. There is fringing along the high-contrast edges where the silhouette meets the background. However, when you're looking at the entire photo, it's difficult to see.

2 Zooming to 100% makes the fringing more apparent. There's a thin blue outline along the black edge of the leaf.

3 Moving the slider for Blue/Yellow Fringe eliminates the problem.

Vignetting

The Vignetting correction fixes a darkening in the corners of a photo caused by the lens. Drag the slider to the right to gradually lighten the corners until the vignetting effect is gone. After adjusting the Amount, you can change the Midpoint to fine-tune the vignetting fix.

Vignetting causes the corners to be noticeably darker than the surrounding areas.

Conclusion

When you're done with all your adjustments in Camera Raw, you can return to Bridge or go straight to Photoshop. As mentioned at the beginning of this chapter, you can always reopen your image in Camera Raw, and all the adjustments will be right where you left them. To save the adjustments and return to Bridge, click the Done button (at the bottom right of the window). If you want to go to Photoshop, click the Open Image button. Working on your image in Photoshop will be covered in Chapter 5.

Chapter 4: Metadata and Keywords

To learn about viewing and editing metadata, we'll go back to Bridge. The metadata features in Bridge are important tools that help you find your photos as well as keep them organized. If you just had a few hundred photos, scrolling through all of them to find the one(s) you're looking for may not be a big deal. However, when you have thousands of photos, scrolling through thumbnails becomes time consuming and tedious. That's where metadata comes in. *Metadata* is information that is tied to your photos. Some metadata shows up automatically; other metadata you have to add. Whichever type it is, you can search for it later. And this ability to search for metadata is what will make your life easier. Chapter 1 introduced metadata, along with the Metadata and Keywords panels. Now it's time to explore these features in depth. First, we'll look at how to view the available metadata and then learn how to add our own metadata.

EXIF and IPTC metadata

EXIF: Metadata that your camera writes when your camera takes a picture; it's info that is specifically about that photo (camera model, aperture, shutter speed, focal length, lens, and so on). You cannot edit or change this information. EXIF stands for Exchangeable Image File Format.

IPTC: Metadata that you choose to add (keywords, copyright, caption, location, city, state, country, and so on). IPTC stands for International Press Telecommunications Council.

The Metadata panel gives you access to both types of metadata. You can use the panel for viewing and editing metadata. The information shown in the panel is for whichever photo is selected. At the top of the Metadata panel is a section called the Metadata Placard. This section lets you see key camera settings and file information at a glance.

Metadata groups

The rest of the Metadata panel is reserved for the following groups of information: File Properties, IPTC Core, Camera Data (Exif), Audio, Video, DICOM and Mobile SWF. Next to each group name is an arrow. Click the arrow to show or hide the information in the group.

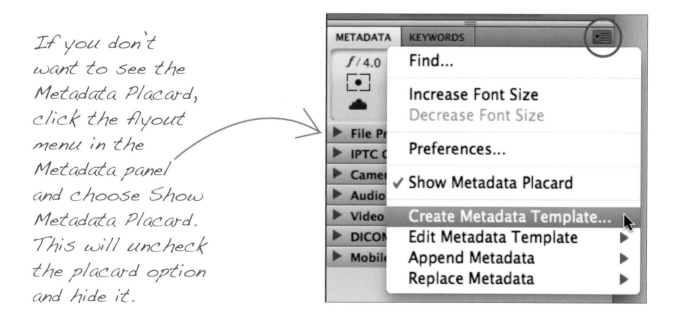

If you don't want to see the Metadata Placard, click the flyout menu in the Metadata panel and choose Show Metadata Placard. This will uncheck the placard option and hide it.

The ones that we'll focus on are File Properties, IPTC Core, and Camera Data.

As mentioned at the beginning of the chapter, there is some metadata you can change and some you can't. The information in the File Properties and Camera Data sections cannot be changed. If you double-click on a field in these groups, you'll get this message: "This property cannot be modified." What you can change is everything in the IPTC Core section. Notice that each field in the IPTC Core section has a pencil icon on the right. This means it can be edited. To edit a field (whether it already has something or is empty), click to the right of the field name or on the pencil. All the fields in the group will change from gray to white, and you can enter information.

When you look at all the IPTC fields, there is a lot of information you *could* enter for each photo. That may seem overwhelming and make you wonder whether it's all really necessary. You certainly don't need to fill in every field. How much you enter depends on what information is important to you.

IPTC FIELDS TO FILL IN

Here are the fields I always fill in:

- All contact information: Creator (your name), Address, City, State/Province, Postal Code, Country, Phone(s), Email(s), Website(s)—all these fields have "Creator": before them to specify it is information about the photographer.

- Location information (where the photo was taken): Sublocation, City, State/Province, Country

- Copyright Notice (© Your Name)

- Copyright Status (Copyrighted)

- Keywords

- Description (if applicable)

Your contact information, copyright notice, and copyright status are important to identify the photo as belonging to you. The rest of the information is image specific and invaluable when searching for photos.

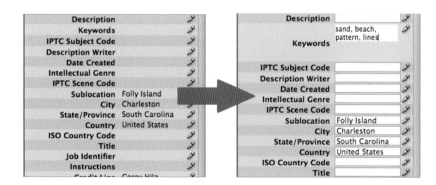

Save your changes by clicking the checkmark at the bottom of the Metadata panel. To cancel the changes you've made, click the circle next to the checkmark.

Metadata Templates

A lot of metadata you want to enter will apply to multiple photos. Instead of having to repeatedly enter the same information for numerous photos, you can take advantage of the Metadata Templates to automate the process. Using these features will make adding metadata much less time consuming. Consider your contact information, for example; that information is always the same no matter the photo. Also, if you have a group of photos taken at the same place, the location information will be the same for the whole group. Metadata Templates are perfect for these situations.

 Access Metadata Templates through the flyout menu in the Metadata panel. Choose Create Metadata Template.

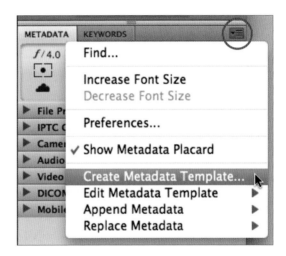

 Give the template a name.

Choose the metadata to include in this template:

☐ Description Writer	:
☐ Date Created	:
☐ Intellectual Genre	:
☐ IPTC Scene Code	:
☑ Sublocation	: US Botanic Garden
☑ City	: Washington
☑ State/Province	: DC
☑ Country	: United States
☐ ISO Country Code	:
☐ Title	:
☐ Job Identifier	:

Enter information in the fields you want to use and then click Save. There are six groups of information (each with an arrow next to them). The first group, IPTC Core, will be the most useful for photographs.

One of the wonderful things about templates is you have to create them only once. After you take the time to create them, you just have to apply them. I now have more than 150 location templates. That sounds like a lot of work to create that many presets, but I did it over time. Each time I photographed at a new location, I'd create a new template. The next time I photographed at that location, the template was right there waiting to be used.

Charleston SC
Colvin Run Mill Location
Deception Falls (WA) Location
Duvall (WA) Location
Eagle Falls (WA) Location
Event Usage Terms
Fairfax Location
Green Spring Location
Huntley Meadows Location
ImageIngester-IPTC
Kenilworth Location
Lake Needwood Location

WHEN I USE TEMPLATES

There are two main purposes for which I use templates: adding my contact information and adding location information. I have created a template that includes only my contact information. I use this one when I'm importing my photos. Recall that in Chapter 1 we created a template called Basic Information for adding contact information to photos on import.

My location templates include sublocation (if applicable), City, State/Province, and Country. After I import my photos, I select all the ones taken at the same location and apply a template to them. The reason I don't add the location information upon import is that I may have photos from multiple locations on one memory card. You could put the contact and location info together in a template.

If you want to edit a template, go to the flyout menu in the Metadata Panel, choose Edit Metadata Template, and then choose the template name from the list.

Second, go to the Metadata panel. Click the flyout menu, go to Replace Metadata, and then choose your template from the list that pops up. That's it! The metadata in the template will be applied to all the selected photos.

See how easy that was? Just a few clicks, and you've added the metadata. The steps are the same whether you want to apply a template to one photo or a hundred.

I've talked a lot about applying these templates, so now let's see how to do it. This procedure takes literally only a couple of steps. First, select the photos to which you want to apply the Metadata Template.

REPLACE VERSUS APPEND METADATA

In the flyout menu, you may have noticed the option Replace Metadata or Append Metadata. Choosing to replace or append is an important decision if your photo already has metadata in the fields used by the template. Append means it won't change a metadata field if something is already entered. For example, say your photo has Chicago listed in the City field, but your template has Seattle listed for the city. If you choose Replace Metadata, the City will change to Seattle. If you choose Append Metadata, the location will stay as Chicago. In most cases you'll want to replace any information that is already there, not append it.

Skip the templates

It's also possible to add the same metadata to a group of photos without using a template. For example, if the info you want to add isn't likely to be needed for other photos, a template might not be necessary. In this situation you can do all the work right in the Metadata panel.

Begin by selecting all the photos you want to add metadata to. Then go to the IPTC Core section of the Metadata panel. The information you enter will be added to all the selected photos. When you have multiple photos selected, you'll see one of three things in the IPTC fields: information that's already been entered, a blank field, or (Multiple values). Here's what they mean:

- **Information:** A field that already has an entry means all the selected photos have the same information in that field.

- **Blank:** None of the selected photos have anything in that field.

- **(Multiple values):** The selected photos do not all have the same information for that field. If you enter something in this field, it will erase whatever is there (for all the photos) and replace it with what you enter.

Metadata panel with multiple photos selected.

IPTC Scene Code	
Sublocation	(Multiple values)
City	(Multiple values)
State/Province	(Multiple values)
Country	United States
ISO Country Code	
Title	
Job Identifier	
Instructions	
Credit Line	Corey Hilz
Source	
Copyright Notice	(c) Corey Hilz
Copyright Status	Copyrighted
Rights Usage Terms	

Keywords

Keywords are literally words assigned to a photo. Keywords are usually used to describe the photo: the location, who or what is in it, and what's happening. The reason they are so helpful is that you can later search for a keyword to find a photo. If you assign the keyword *bee* to every photo with a bee in it, then all you have to do is search for *bee* and you'll find all your bee photos.

Keywords are more likely to be nouns (*house, lake, woman, child, hat, mountain*) but can also be adjectives (*fast, calm, tranquil, colorful*). Keywords should be single words unless they are formal names. A red barn would be keyworded as *red* and *barn*, not *red barn*. On the other hand, a photo of the Washington Monument would be given the keyword *Washington Monument* because it's a formal name.

You can add keywords using either the Metadata or Keyword panels.

HOW MANY KEYWORDS?

You can add as many keywords as you want, but using lots of keywords is not a necessity. Try to add at least a few keywords to each photo. When choosing them, let the key elements in the image guide you to the best words to use. Think about it this way: What words would come to mind if you were trying to find the photo? Adding keywords may seem tedious at first, but when you get into the habit, it'll go much faster. I prefer to add keywords after I've decided which photos I'm keeping and which I'm deleting. Because keywords are somewhat specific to an individual photo, I don't want to spend my time keywording photos that I end up sending to the trash.

Metadata panel

In the Metadata panel, there is a Keywords field in the IPTC Core section. Click the Keyword field box, and you can type in keywords for the selected photo. Use a comma and space to separate the keywords.

This method can be used to add keywords to one or more photos at a time. The keywords entered will be added to all the selected photos.

Keywords panel

The Keywords panel lists all the keywords that have been assigned to photos. The keywords shown are not just ones assigned to the photos you're currently viewing, but for any photo that has been viewed in Bridge.

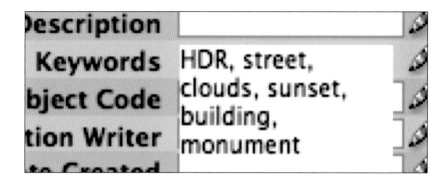

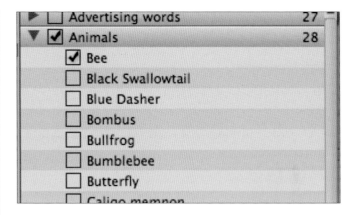

The keywords are organized in a hierarchy. Creating a hierarchy for your keywords helps keep them organized. *Hierarchy* simply means putting your keywords into groups. Each keyword with an arrow next to it means it's part of a keyword group. Click the arrow to show the sub keywords.

Using this organization method allows you to more easily keep track of all your keywords. Create keyword groups for categories of keywords such as animals, locations, people, and plants. Or make them more specific: reptiles, mammals, and birds. The number to the right of the keyword group is how many keywords it contains.

Keywords can be rearranged by dragging and dropping. This gives you the flexibility to change what group a keyword is in, as well as to create a sub keyword by dropping one keyword on top of another.

Dragging and dropping *Orchidaceae* on top of *Orchid* groups them together, making *Orchidaceae* a sub keyword of *Orchid*.

The keywords assigned to the selected photo are listed at the top of the Keywords panel.

METADATA	**KEYWORDS**	▼☰

Assigned Keywords: building; clouds; HDR; monument; street; sunset

The icons at the bottom right of the Keywords panel are used for adding and deleting keywords.

Add a
sub keyword

Delete the
selected keyword

Add a keyword

In the Keywords panel, the keywords are always alphabetically organized.

In a keyword hierarchy, if you check the box for the top keyword, only that keyword is added, not all the keywords in the group.

To assign keywords, select one or more photos; then click the box next to the keyword. A checked box means that a keyword is assigned to the selected photo(s). If you see a horizontal line through the box, it means multiple photos are selected, but only some of them have that keyword assigned. To assign that keyword to all the selected photos, click the horizontal line and it'll change to a checkmark.

In the Keywords panel, you can also search for keywords. At the bottom of the panel is a search box. Begin typing, and keywords that match your search will be highlighted. You don't even have to type in a full word. Bridge will highlight words that include whatever you type.

By default, Bridge will search for any keyword that contains what you type. If you enter **li**, the list shows words that have *li* somewhere in them. The *li* character combination doesn't have to be at the beginning. For additional options, click the magnifying glass in the search box. From the pop-up menu, you can also choose for the results to Equal (match) or Start With what you type.

When you search, you'll notice one of the words is highlighted in green instead of yellow. The green one is the selected keyword from the search results. If you press the Return/Enter key, the green highlighted keyword will be added to the selected photo(s). You can change which word is highlighted green by clicking the left or right arrows next to the search box.

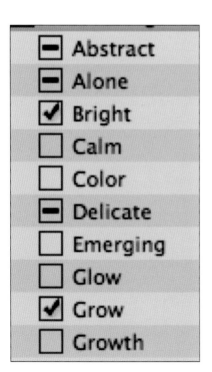

Filter panel

The Filter panel offers a fast way to sort photos based on metadata. Click the arrow next to one of the categories to show a list of the items it contains.

Next to each item is the number of photos in the current folder that meet that criterion. Click one of these items to display just those photos. Think of the filter as a mini-search. If you go to the Ratings category and click on No Rating, Bridge will show you all the photos that don't have a rating.

To control which categories are visible, click the Filter panel flyout menu. The menu contains a list of all the possible categories. Clicking a category will uncheck it and remove it from the Filter panel. To make category visible again, simply return to the flyout menu and select it. You'll notice that not all the checked categories appear in the Filter menu. For a category to appear, at least one photo in the folder must match the criteria for the category. For instance, if you have only photos in the folder,

there's not likely to be anything that matches the Genre, Key, Tempo, or Loop categories.

Searching

Now that we've gone through all the effort of adding metadata such as location information and keywords, what are we going to do with it? This information is indispensable when you're searching for a particular photo or photos. For a basic search, go to the Quick Search box in the top-right corner of the Bridge window. Enter in the search term; then press Return/Enter. Bridge will search filenames and keywords of the files in the current folder as well as any subfolders. The Content panel will display any matching images.

For advanced search options, go to Edit>Find. In the Find window, there are many options for structuring the search—from where to search to exactly what to look for. The choices available are the same as what you see when creating a smart collection.

To clear the search results, click the X in the top-right corner of the Content panel. Clearing the Quick Search box will not remove the search results.

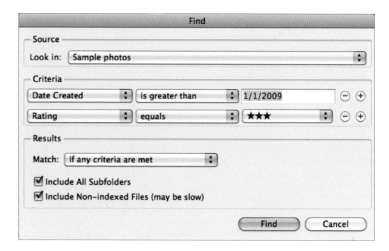

Source

Choose the folder you want to search.

Criteria

Select the criteria for the search. You can use multiple criteria; plus there are many options and qualifiers for the criteria. Add multiple criteria to make the search more selective.

Results

Match: Choose whether search results have to match all the criteria or just one.

Include All Subfolders: Decide whether the search looks in folders that are within the Source folder.

Include Nonindexed Files: The nonindexed files have not been viewed in Bridge before, and because Bridge would be looking at them for the first time, searching them can take longer.

I mentioned smart collections earlier; they are another feature that takes advantage of the metadata available in your photos. For more information

about smart collections, see the "Organizing" section in Chapter 1.

Batch Rename

The Batch Rename feature offers a quick and easy way to rename a large number of photos at once. Select the photos you want to rename; then go to Tools>Batch Change. There are four sections in the Batch Rename window.

Presets

There will be only a couple of preloaded options. If you want to be able to reuse the options you select below, you can save your own preset. To do so, first set up the rest of the options in the Batch Rename window. Then come back to the Presets section, click Save, and give the preset a name.

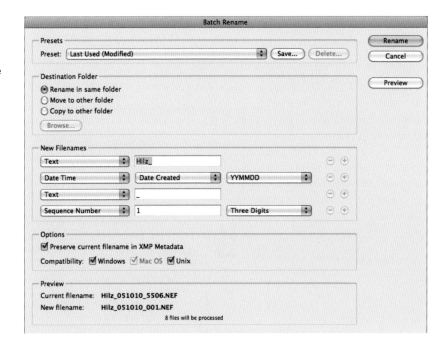

Destination folder

Rename: Photos are renamed and stay in the same folder.

Move: Photos are renamed and then moved to a different folder.

Copy: Photos are copied and the copies are renamed. The originals are not renamed.

New filenames

Add or remove criteria to create the new filename.

Options

Check the box for Preserve… if you want to save the current filename in the photo's metadata. Check the boxes for Compatibility to make sure the filename is compatible with various operating systems.

Preview

Preview provides an example of one of the new filenames. Use this preview to make sure the filename will turn out as you expect.

Conclusion

As you can see, all this metadata is a big help for finding your photographs. It may be a hassle, but if you get in the habit of entering location and keyword information, you'll reap the benefits when it comes time to find a particular image. Let's review what you can do. The Metadata panel can be used to review technical data about your photographs or enter your own information in the IPTC Core section. When you have metadata that you'll be using repeatedly (such as locations), don't forget to take advantage of the template options. You can add keywords to each photo using the Metadata or Keywords panels. To find photos based on metadata, you can use the Filter panel or the search feature. Using these search features is the way to leverage all the information you've entered. It also keeps you from having to scroll through various folders and hundreds or even thousands of photos!

Chapter 5: Photoshop: Global Adjustments

AFTER YOU'VE DONE AS MUCH as possible to your photographs in Camera Raw, the next step is to go to Photoshop for any final adjustments. However, the more you can do in Camera Raw, the better because it's all nondestructive. How much you're able to do in Camera Raw depends on what version you're using. For instance, not all versions of Camera Raw have the Adjustment Brush. Without the Adjustment Brush, you are limited to primarily global adjustments and will find more of a need to go Photoshop. In the latest version of Camera Raw, however, you can do so much that you'll find you don't always need to go to Photoshop. And that's a good thing! No need to make more work for yourself!

The adjustments you can make in Photoshop can either be global or local. *Global* adjustments are those that affect the entire image. *Local* adjustments change only part of the image. Begin with global adjustments and then move on to local adjustments. Depending on how much you're able to do in Camera Raw, you may not need to do any global adjustments. You may just need to use Photoshop to target specific areas of the photo with local adjustments.

This chapter focuses on working with adjustment layers and other nondestructive techniques to perform global adjustments. The adjustments covered include Curves, Levels, Exposure, Brightness/Contrast, Vibrance, and Hue/Saturation. You'll also learn how to make black-and-white conversions and use the Lens Correction feature. In Chapter 6 we'll focus on local adjustments and retouching. Even if you are looking to make only local adjustments, I recommend you read about adjustment layers in this chapter because that is the basis for selectively applying adjustments later.

Opening your photo in Photoshop

You can open a photo in Photoshop either from Bridge or straight from Camera Raw. If you're already in Camera Raw, click the Open Image button at the bottom of the Camera Raw window. If you're in Bridge, double-click the photo you want to open in Photoshop. Depending on the file type, this may open the photo in Camera Raw; then you have to click the Open Image button as just described. Here's a trick: Hold down the Shift key while you double-click the photo in Bridge. This forces the file to open directly in Photoshop, skipping Camera Raw.

Toolbox

On the left side of the screen in Photoshop is a floating strip of icons called the Toolbox. Each icon represents a tool; click the icon to select the tool. If you hover your mouse pointer over a tool, the tool's name will appear. The letter after the tool's name is the keyboard shortcut to select that tool. Most of the tool icons are actually a group of tools. To see the list of tools in a group, right-click, or click and hold, the tool icon. Pick a different tool in the group by clicking its name in the pop-up list.

For your reference, here's the layout of the Toolbox and all the tool groups.

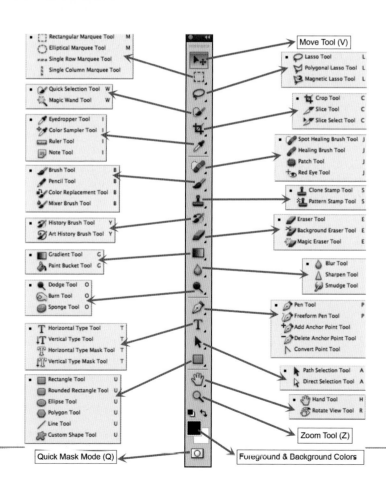

Options Bar

The Options Bar is located directly above your photograph. The options available are specific to the tool selected in the Toolbox. When you switch tools, you'll see the content of the Options Bar change.

This is what the Options Bar looks like when the Brush Tool is selected.

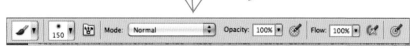

Layers panel

When you're making any adjustments in Photoshop (global or local), I recommend you use adjustment layers whenever possible. Adjustment layers are called *nondestructive adjustments*. This means an adjustment does not change your original image. This feature gives you the ability to change or experiment with the adjustment as much as you'd like, and it never affects the quality of your original photo.

Adjustment layers appear in the Layers panel, so let's first look at what you'll see in the Layers panel as you work with your photos. If you don't see the

Layers panel on your screen, go to Window>Layers. The following screen shot shows a Layers panel with a number of layers. You won't see a bunch of layers like this when you first open a photo, but I wanted to show what kinds of things can appear in the Layers panel as you add layers. Use the following screen shots as a reference while you work with layers.

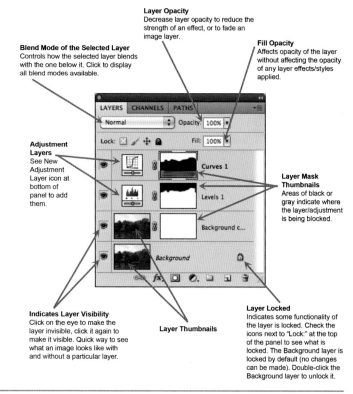

Blend Mode of the Selected Layer
Controls how the selected layer blends with the one below it. Click to display all blend modes available.

Layer Opacity
Decrease layer opacity to reduce the strength of an effect, or to fade an image layer.

Fill Opacity
Affects opacity of the layer without affecting the opacity of any layer effects/styles applied.

Adjustment Layers
See New Adjustment Layer icon at bottom of panel to add them.

Layer Mask Thumbnails
Areas of black or gray indicate where the layer/adjustment is being blocked.

Indicates Layer Visibility
Click on the eye to make the layer invisible, click it again to make it visible. Quick way to see what an image looks like with and without a particular layer.

Layer Thumbnails

Layer Locked
Indicates some functionality of the layer is locked. Check the icons next to "Lock:" at the top of the panel to see what is locked. The Background layer is locked by default (no changes can be made). Double-click the Background layer to unlock it.

Here is a screen shot explaining the Lock options at the top of the Layers panel.

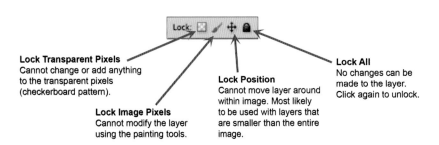

Lock Transparent Pixels
Cannot change or add anything to the transparent pixels (checkerboard pattern).

Lock Image Pixels
Cannot modify the layer using the painting tools.

Lock Position
Cannot move layer around within image. Most likely to be used with layers that are smaller than the entire image.

Lock All
No changes can be made to the layer. Click again to unlock.

Last, but not least, here you can see some details about the icons at the bottom of the Layers panel.

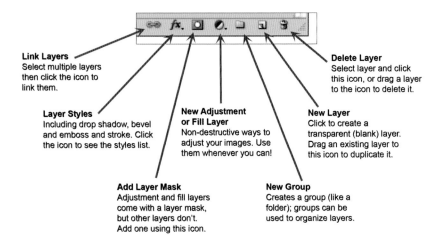

Link Layers
Select multiple layers then click the icon to link them.

Layer Styles
Including drop shadow, bevel and emboss and stroke. Click the icon to see the styles list.

Add Layer Mask
Adjustment and fill layers come with a layer mask, but other layers don't. Add one using this icon.

New Adjustment or Fill Layer
Non-destructive ways to adjust your images. Use them whenever you can!

New Group
Creates a group (like a folder); groups can be used to organize layers.

New Layer
Click to create a transparent (blank) layer. Drag an existing layer to this icon to duplicate it.

Delete Layer
Select layer and click this icon, or drag a layer to the icon to delete it.

Adjustment Layers

Now that you're familiar with the various pieces of the Layers panel, let's look at working with adjustment layers. Using adjustment layers is the way to go for the most flexibility and control over fine-tuning your photographs. As I mentioned earlier, adjustment layers give you a nondestructive way to adjust your image. They offer flexibility when you change your mind or just want to experiment.

We'll go through an overview of adjustment layers and the Adjustments panel and then turn to using common adjustments.

The easiest way to add an adjustment layer is to go to the bottom of the Layers panel and click on the New Adjustment Layer icon.

2 A list pops up with all the possible adjustment (and fill) layers. The adjustment layers you're more likely to use are Brightness/Contrast, Levels, Curves, Exposure, Vibrance, and Hue/Saturation. You can use as many adjustment layers as you like. You can even use more than one of the same adjustment layer (that is, two Levels layers).

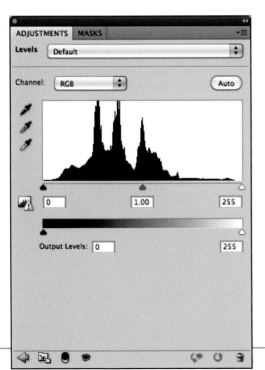

3

Click the name of the adjustment you want, and the Adjustments panel appears with the options for that item (if you're using CS3 or earlier, you'll see a dialog box instead). For this example, I'm using a Levels adjustment layer.

After making your adjustments, click on the tab for the Layers panel to switch back to the list of layers (in CS3 or earlier, click OK in the dialog box). I'll go over the options available in the Adjustments panel shortly.

In the Layers panel, there are now two layers: a Background layer and the adjustment layer you just created. The Background layer is your photograph. When you open a photo for the first time in Photoshop, there will always be a Background layer.

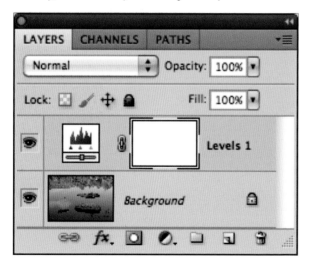

In the Layers panel, you can see that the Levels adjustment is on its own layer, making it separate from the image itself (the Background layer). This is what makes the Levels adjustment layer (or any adjustment layer) nondestructive. It's not actually changing the pixels of the image. With the Levels adjustment layer above my image, it's as though I've laid a filter over the image and the filter is my Levels adjustment. The adjustment is independent of the image.

You can "turn off" (make invisible) the layer to see what the photo looks like without the adjustment by clicking the eye icon next to the layer (click again to turn it back on).

If you decide you don't want an adjustment anymore, you can delete it by dragging it to the trashcan at the bottom of the Layers panel.

You have all these options available to you now and later... even after you've added other layers—all without affecting the quality of the photograph.

Another benefit of adjustment layers is being able to modify their settings. Double-click the adjustment layer, and you'll switch to the Adjustments panel for that layer (in CS3 or earlier, a dialog box will appear). All the settings (sliders, number values, and so on) will be right where you left them when you first created the adjustment layer. This is helpful for a couple of reasons: (1) You can review the settings you used, and (2) you can change the settings.

Let's compare this to making a Levels adjustment through the Image menu. Going to Image>Adjustments>Levels brings up the Levels dialog box.

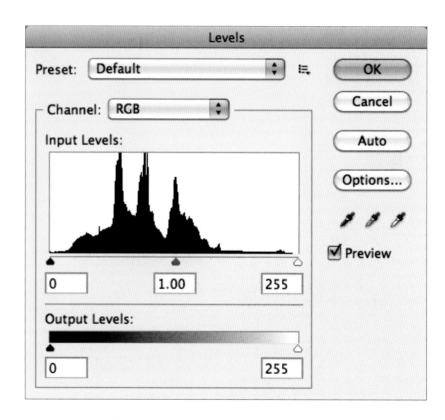

The Levels options look just like what was available when the Levels Adjustment layer was added. And they are; the options are exactly the same. You move the sliders to adjust your image and then click OK. However, after you click OK, the pixels of the image are actually changed, which is why it's considered a destructive adjustment. You can't go back and change the settings. If you don't like the results, you have to use Undo (Edit>Undo) and then try again.

This is the same for any adjustment you add as an adjustment layer compared to choosing it from the Image>Adjustments menu. I recommend using adjustment layers whenever you can!

You can also add adjustment layers through the Layer menu. Just go to Layer>New Adjustment Layer and then choose the Adjustment.

Adjustments panel

Much of what you see in the Adjustments panel will vary depending on which adjustment you're working with. However, some items are common to all adjustment layers and will always be there. Here's what they are.

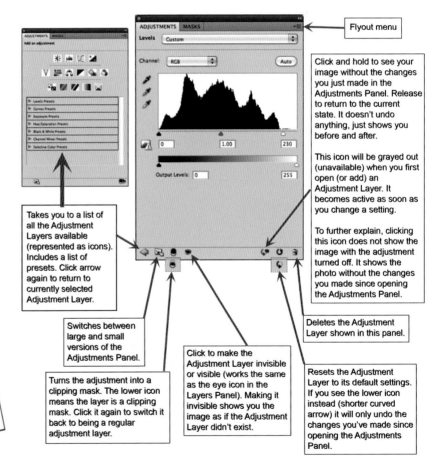

Flyout menu

Click and hold to see your image without the changes you just made in the Adjustments Panel. Release to return to the current state. It doesn't undo anything, just shows you before and after.

This icon will be grayed out (unavailable) when you first open (or add) an Adjustment Layer. It becomes active as soon as you change a setting.

To further explain, clicking this icon does not show the image with the adjustment turned off. It shows the photo without the changes you made since opening the Adjustments Panel.

Takes you to a list of all the Adjustment Layers available (represented as icons). Includes a list of presets. Click arrow again to return to currently selected Adjustment Layer.

Switches between large and small versions of the Adjustments Panel.

Turns the adjustment into a clipping mask. The lower icon means the layer is a clipping mask. Click it again to switch it back to being a regular adjustment layer.

Click to make the Adjustment Layer invisible or visible (works the same as the eye icon in the Layers Panel). Making it invisible shows you the image as if the Adjustment Layer didn't exist.

Deletes the Adjustment Layer shown in this panel.

Resets the Adjustment Layer to its default settings. If you see the lower icon instead (shorter curved arrow) it will only undo the changes you've made since opening the Adjustments Panel.

Common adjustments

Earlier in the chapter I mentio-ned that you're likely to use the following adjustments: Brightness/Contrast, Levels, Curves, Exposure, Vibrance, and Hue/Saturation. We'll take a quick look at Brightness/Contrast, Exposure, Vibrance, and Hue/Saturation first because their settings are fairly straightforward. We'll then go a little more in-depth with Levels and Curves.

Brightness/Contrast

The Brightness and Contrast sliders have the same effect as their comparable sliders in Camera Raw. Changes in Brightness lighten or darken the image. A Brightness change affects the midtones in an image more than the highlights or shadows. The Contrast slider increases or decreases contrast. If you check the Use Legacy box, it will be harder to make subtle adjustments because even small changes to the slider position can have significant effects.

Exposure

The Exposure slider in Photoshop has the same function as the Exposure slider in Camera Raw. It lightens or darkens the image, primarily affecting highlight and midtone areas, with a lesser effect on shadow areas.

The other adjustment that you may want to use is Gamma Correction. It works similarly to Brightness, lightening or darkening midtones.

Vibrance and Hue/Saturation

Saturation and Vibrance both increase the intensity of colors but do so in different ways. Saturation equally increases/ decreases the intensity of colors in an image. Vibrance, on the other hand, applies saturation selectively and in a more subtle manner. Intensity is increased in colors that aren't saturated. It does not change colors that are already very saturated and does not change the saturation of skin tone colors.

Notice that there are Saturation adjustments within both Hue/ Saturation and Vibrance. The effect of these Saturation sliders is not the same. The Saturation adjustment within Vibrance is not as strong as the Saturation adjustment within Hue/Saturation. Here are the three adjustments in order from least to greatest intensity: Vibrance, Saturation (in Vibrance), Saturation (in Hue/ Saturation).

The Hue/Saturation adjustment (in Photoshop CS4 and later) also has the Targeted Adjustment tool found in Camera Raw. To select this tool, click on the pointing finger in the top left of the Hue/Saturation Adjustment panel.

Move the mouse pointer over the photo, and you'll notice it changes to an eyedropper.

To use the Targeted Adjustment tool, you just need to click and drag. Begin by clicking on the color whose saturation you want to adjust; then drag right to increase saturation or left to decrease saturation. For more details about using this tool and what adjustments it makes, see Chapter 3.

Levels

Levels is a great initial adjustment to make to your photos. Simply moving two or three sliders can be a big improvement to the tonality of your image as well as the intensity of the colors. Here are some tips for making the most of Levels.

You'll want to work with the three sliders directly below the

histogram. Moving the Black and White sliders adjusts the black and white points in a photo. This allows you to set the lightest and darkest tones of the image. The Gray slider adjusts the midtones, or gamma. Move it to the left to lighten the midtones or to the right to darken them. In almost all cases, if I move the Gray slider, it's to the right for a subtle or significant darkening of the midtones. Moving these sliders can make a big difference to an image that looks a bit flat or washed out. The more the sliders are moved, the more dramatic the change in the photo. Remember, this description is just a guideline; you should use the actual appearance of your photo to determine the best position for the sliders.

WHAT IS LEVELS ACTUALLY DOING?

The Levels adjustment is making Photoshop stretch out the tonal range in your photo using brightness levels. The gaps at either end of the histogram tell you that initially there was nothing solid black or solid white in the photo. By moving the Black and White sliders, you are telling Photoshop what tone should be black and what tone should be white. This results in adding more contrast.

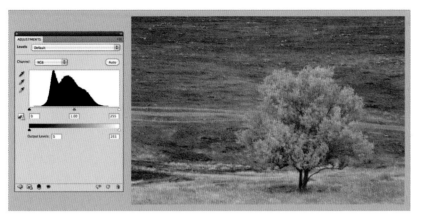

1

We begin with the original photo before any adjustments to Levels. The Black and White sliders are always initially positioned at the left and right ends of the histogram box. Use this rule of thumb to help you decide how far to move the sliders: Move them toward the middle until they are below the place where the histogram begins to rise up at either end. How big of a move this is depends on the histogram of the individual photo.

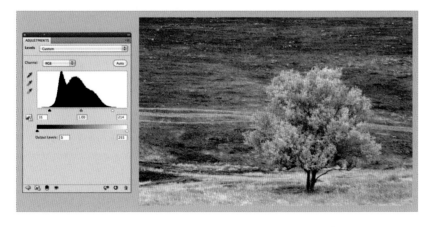

2

Here, the Black and White sliders are moved in to the place where the ends of the histogram begin to rise up. Notice the dramatic change to the photo. For this image, the Black slider is at 35 and the White slider at 213.

3

The final adjustment is a small move of the Gray slider to the right, to slightly darken the midtones. This adjustment gives a richer appearance to the colors and removes the slightly washed-out look.

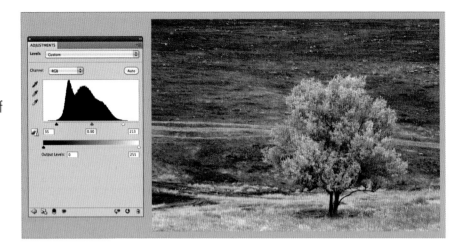

Curves

Curves is a powerful tonal adjustment tool, but it's not necessarily obvious how to use it effectively. We'll look at the basics of using Curves and common adjustments and then some more advanced techniques. The name Curves may seem misleading because when you choose a Curves adjustment, all you see is a diagonal line. Where is the curve? Well, what happens is you manipulate that straight line into a curve. This is done by adding points to the curve and then moving the points around to bend the line.

WORKING WITH POINTS ON THE CURVE

- Click anywhere on the curve to add a point to it. When you click on the curve, a tiny square appears. Each square is a point.
- You can have multiple points on the curve.
- When there are multiple points, only one is selected at a time. The selected point is black; nonselected ones are outlines. To select a point, click on it.
- Reposition a point by clicking and dragging it along the line.
- To delete a point, click on it to select it and then press the Delete key.

The grid in the Curves box can either be large or small squares.
I prefer the small squares because they give me a more precise reference when bending the curve. To switch between large and small squares, hold down the Option (PC: Alt) key and click anywhere on the grid.

Let's look at some basic Curves adjustments, starting with one point on the curve and then two.

To quickly and easily lighten or darken your photo, place one point at the middle of the curve. To lighten your photo, drag the point up; to darken, drag it down. The further you drag the point, the more you will lighten or darken the image.

As soon as you add a point to the curve, you can start bending it. To bend the curve, click and drag the point in any direction. It's easier to try than to describe. So go ahead and add a point to the curve; then click the point and drag your mouse around. You'll see the curve change shape as you drag the point around. Think of the curve as a string of rubber that's tied down at either end. You're grabbing the rubber and stretching it, changing its shape.

Add one point to the middle.

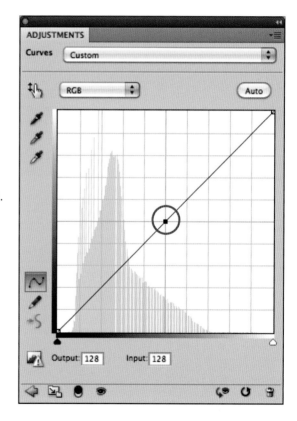

Drag up to lighten. Drag down to darken.

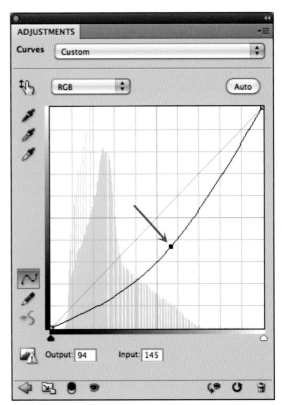

Add contrast with Curves

Using Curves to add contrast gives you more control than using the regular contrast adjustment. To add contrast with Curves, you need to bend the curve into a slight S-shape using two points.

Add two points: place one point in the upper right and the other in the lower left.

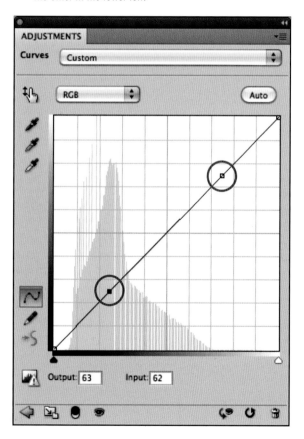

Drag the upper point up and to the left a small amount.

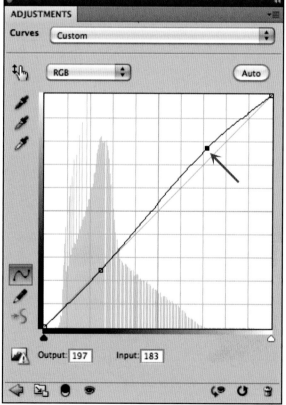

3 Drag the lower point down and to the right a little. The curve now has a slight S-shape.

You can fine-tune the amount of contrast by adjusting the position of the points. If you move the points further out (into a more distinct S-shape), you will increase the contrast. You can move the points back in (reducing the S-shape) for less contrast. Experiment by moving only one of the points or moving the points different amounts. A little bit goes a long way here. The slight S-shape shown here produces a moderate increase in contrast.

Take a look at this before-and-after comparison to see how much of a difference a Curves contrast adjustment can make.

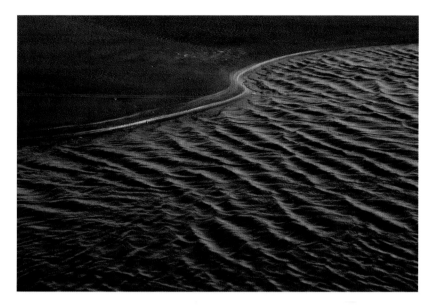

Original photo.

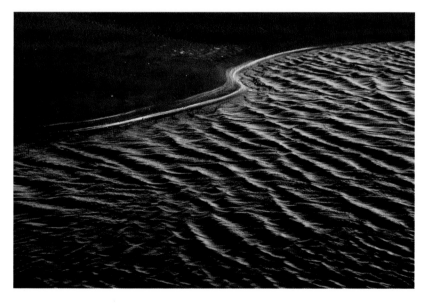

With added contrast using Curves.

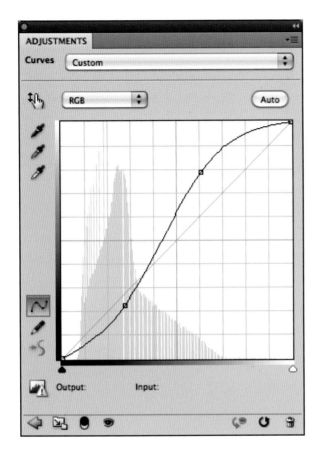

Curves contrast adjustment used.

Targeting tonalities with Curves

Now that you understand the basics of Curves, let's find out how to target specific tonalities in photos. For instance, you can use Curves to just darken the dark tones or lighten the light tones.

Using two or more points on the curve offers greater control over what the curve is changing.

The location of a point on the curve determines which tones are affected when you move that point. Sections of the curve represent different tonalities. The lower part of the curve represents dark tones, the center is middle tones (tones that aren't light or dark), and the top section is light tones. There are gradations along the bottom and left sides of the Curves grid that represent this transition.

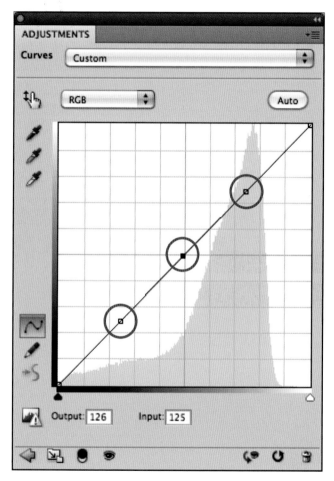

Think of adding three equally spaced points along the curve. Moving the lower point affects the dark tones in your photo. The center point changes the midtones, and the upper point targets the light tones. Moving a point down darkens the tones; moving a point up lightens them.

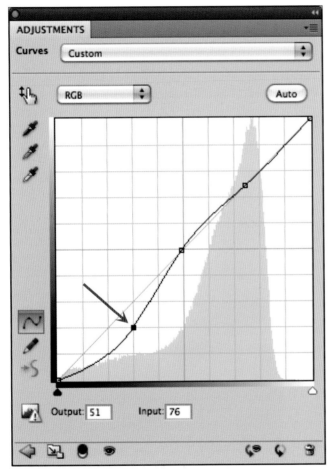

2

Pulling the lower point down darkens the dark tones (the chain).

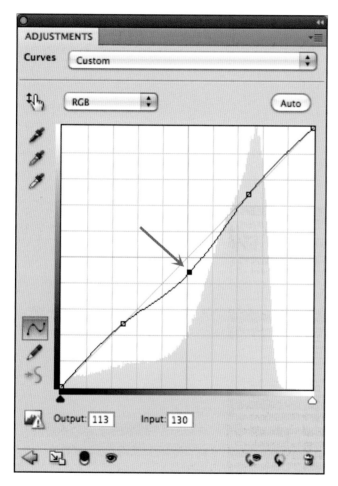

Moving the middle point down darkens the midtones (portions of the concrete and around the chain).

Dragging the upper point up lightens the light tones (concrete).

As you saw in the previous examples, the location of the point and the way it's moved affect the tones that are changed. However, that's not the only reason we're able to target certain tones. The additional points on the curve (that are not moved) play a key role. These points keep the rest of the curve from moving when you drag one point. At the beginning of the "Curves" section, I demonstrated how you could place a point at the center of the curve and then pull the curve up or down to lighten or darken the photo. If you look back at those examples, you'll notice that the entire curve changed shape when the point was moved.

In comparison, take a look at the photo in the previous set where the middle point was moved. Only the center of the curve moved. The rest of the curve remained unchanged because of the additional points on the curve. Those added points "lock down" certain areas of the curve, preventing it from moving. Additional points could be added to lock down more of the curve and even more precisely control what tones are affected.

Targeted Adjustment tool for Curves

In Photoshop CS4 and later, you can also adjust Curves by using a special tool that allows you to click and drag directly on your photograph.

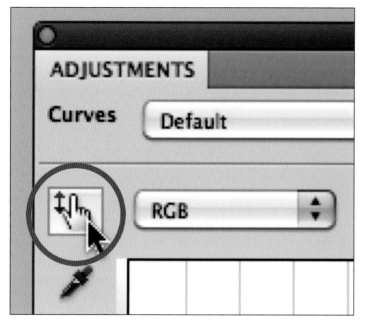

To select the Targeted Adjustment tool, click on the pointing finger in the top left of the Curves Adjustments panel.

2 Move the mouse pointer over the photo, and you'll notice it changes to an eyedropper.

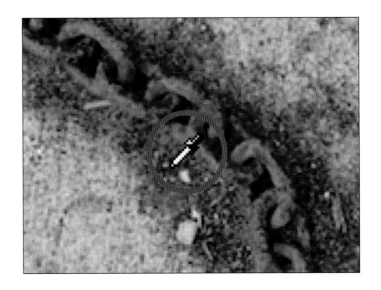

3 As you move the eyedropper over the photo, look back at the Curves panel. You'll see a circle moving along the curve; the position of the circle along the line tells you what tone you are pointing to in the image.

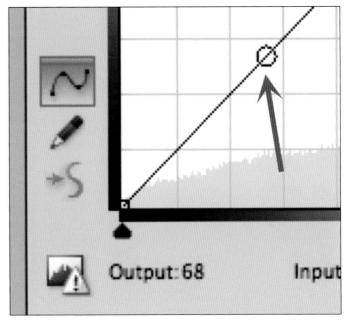

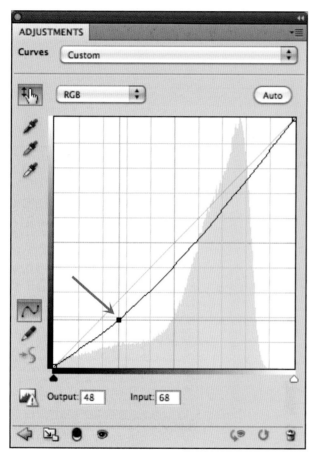

To use the Targeted Adjustment tool, you just need to click and drag. Begin by clicking on the part of the photo you want to adjust; then drag up to lighten or down to darken. When you click on the photo, a point is added to the curve. Then as you drag, the curve is bent to adjust the tone. For this image I clicked on a dark part of the chain and then dragged down to further darken the tones.

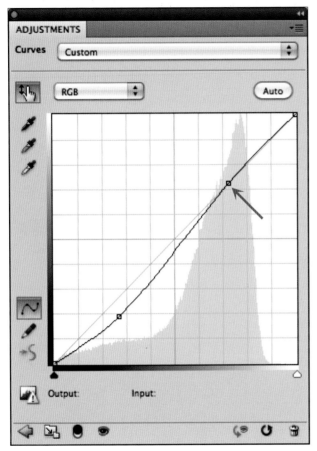

Although the dark tones were darkened the most, the rest of the tones were also darkened to some degree. Now the light tones are too dark. I can continue to use the "on image" adjustment to improve the light tones. All I need to do is click on the light concrete and drag up to brighten the light tones.

Working with the "on image" adjustment can help take some of the mystery out of using Curves. By being able to work directly on your photo, you're able to focus on what part of the image you want to change instead of where to click on the curve.

As you can see, Curves can do quite a lot. Take some time and practice to get the hang of where to add points on the curve and where to drag them. It'll be worth your time!

Converting to black and white

As you'll recall from Chapter 2, it's possible to convert a photo to black and white using Camera Raw. The black-and-white conversion settings in Photoshop are very similar to those found in Camera Raw. Consequently, making the conversion in Photoshop will not produce a significantly different type of black-and-white photograph. Because you'll be doing most of your image adjustments in Camera Raw, I recommend converting to black and white in Camera Raw whenever possible. So why would you need to do it in Photoshop? Perhaps you want

a black-and-white version in addition to a color version of a photo. Or you want to use some of the adjustments or retouching tools in Photoshop before making the conversion.

In Photoshop the process for converting a photo to black and white is easy to do. All you have to do is add an adjustment layer. Go to the bottom of the Layers panel, click on the New Adjustment Layer icon, and select Black and White.

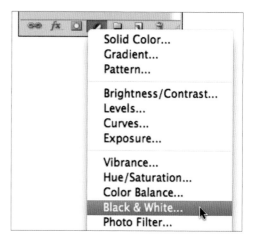

A Black and White adjustment layer is added to the Layers panel.

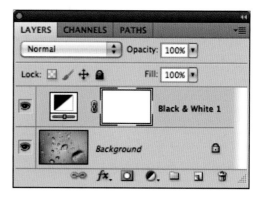

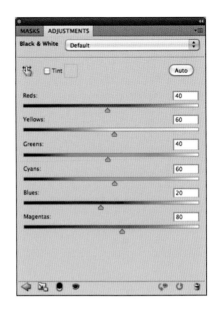

The Adjustments panel now displays the settings for the Black and White adjustment layer. The list of color sliders is similar to those found in the HSL/Grayscale panel in Camera Raw (there are two additional sliders in Camera Raw). They function the same as their counterparts in Camera Raw. See Chapter 3 for details about how to use these adjustments.

Move the mouse pointer over the photo, and you'll notice it changes to an eyedropper. To use the Targeted Adjustment tool, all you need to do is click and drag. Begin by clicking on the part of the photo you want to adjust; then drag left to lighten or right to darken. For more details about what adjustments this will make, see Chapter 3.

Targeted Adjustment tool for B&W

The Black and White adjustment (in Photoshop CS4 and later) also has the Targeted Adjustment tool found in Camera Raw.

To select this tool, click on the pointing finger in the top left of the Black and White Adjustments panel.

Combining color with B&W

To have parts of a photo in color with the rest in black and white, paint with black on the layer mask for the Black and White adjustment layer. Wherever you paint with black on the layer mask will block the B&W conversion, revealing the original color image. For more details on layer masks, see Chapter 6.

Smart filters

When you choose an item from the Filter menu, the effect of that filter is applied directly to the photo. There are no adjustment layers or layer masks. Smart Filters give you a way to use filters nondestructively. You'll be able to revisit the filter settings just like with an adjustment layer. The steps to set things up for Smart Filters are pretty simple; then you can experiment with using filters and other adjustments.

Change your Background layer into a Smart Object. Click on the Background layer and then go to Filter>Convert for Smart Filters. After a moment the Background layer will be renamed Layer 0, and an icon will appear in the corner of the layer thumbnail. The icon indicates the layer is now a Smart Object, which allows you to use Smart Filters. Now it's time to use a filter. This part of working with filters hasn't changed. Choose one from the Filter menu, adjust the filter settings as you'd like, and then apply them.

After using a filter, you'll notice a couple of things have been added under Layer 0. The white box is a layer mask. Underneath the mask is the name of the filter you used. And here's the benefit of the Smart Filter: double-click the filter name, and the filter settings will open. All the settings are right where you left them, reminiscent of adjustment layers. This feature allows you to go back and change the settings at any time.

You can also use multiple Smart Filters on a photo. Choose another one from the Filter menu, apply the settings, and you'll see it listed in the Layers panel with the first filter you used. The layer mask for the Smart Filters can be used to selectively apply the filter effects. The downside is there is only one layer mask for all the Smart Filters. If you have multiple Smart Filters, they do not all have their own layer masks.

Smart Filter tips

- To turn off a Smart Filter, click the eye icon next to the filter name. Click again to turn it back on. This may take a few seconds or more depending on the file size and complexity of the filter.

- To delete a Smart Filter, drag the filter name to the trashcan icon at the bottom of the Layers panel.

- If you're using plug-ins (software add-ons from other companies) that show up in the Filter menu, they can also be applied as Smart Filters.

Shadows/Highlights

Shadows/Highlights is an adjustment found in the Image menu (Image>Adjustments>Shadows/Highlights). It's used for lightening shadows and darkening highlights, which is helpful for high-contrast images. However, it's one of the few adjustments that's not available as an adjustment layer. But there is a workaround! And that's why I put this discussion after the "Smart filters" section. Even though Shadows/Highlights is not in the Filter menu, it can be used as a Smart Filter. First, convert your Background layer for Smart Filters (Filter>Convert for Smart Filters); then go to Image>Adjustments>Shadows/Highlights.

In the Shadows/Highlights dialog box, adjust your image with the Amount sliders for Shadows and/or Highlights. For more advanced settings, click the box at the bottom for Show More Options.

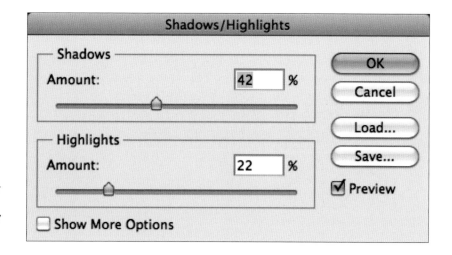

After you make your Shadows/Highlights adjustments, click OK and you'll see Shadows/Highlights listed as a Smart Filter in the Layer panel. This is one more way to keep your work as nondestructive as possible!

Lens Correction

Lens Correction is for fixing distortion, straightening photos, and removing chromatic aberration. Lens Correction is found in the Filter menu. In CS5, go to Filter>Lens Correction. For CS4 and earlier, go to Filter>Distort>Lens Correction.

A new window opens displaying your photo and the Lens Correction adjustments. These adjustments are the same as those found in Camera Raw in the Lens Corrections panel. If you're using CS4 or earlier, Camera Raw doesn't have Lens Correction, so you should take care of these adjustments here in Photoshop. Refer to Chapter 3 for details about what these adjustments do and how to use them.

Below the photo are display options. Click the plus or minus buttons to zoom in or out on the photo. Or you can click the arrows next to the percentage to display a list of zoom levels.

- **Preview:** Uncheck the box to see the uncorrected photo.

- **Show Grid:** Use the grid lines as a reference when making the Lens Correction adjustments. They'll help you determine when the vertical and/or horizontal lines in your photo are straight.

- **Size:** Set the size of the boxes in the grid.

- **Color:** Set the color of the grid lines.

Because Lens Correction is listed in the Filter menu, it can be used as a Smart Filter, as described in the "Smart Filters" section.

Conclusion

Whatever type of adjustment you're making in Photoshop, I encourage you to take a nondestructive approach. Utilize adjustment layers and Smart Filters whenever possible. Working with nondestructive techniques gives you the most flexibility without impacting the quality of your image. In the next chapter, we will find out how to selectively apply adjustments plus how to use Photoshop's retouching tools.

Chapter 6: Photoshop: Selective Adjustments and Retouching

In CAMERA RAW WE USED the Adjustment Brush to selectively apply adjustments. The equivalent in Photoshop is using layer masks along with adjustment layers. By using layer masks, you can take any of the adjustments discussed in Chapter 5 and apply them only to the areas of the photo that you want. After exploring these selective adjustments capabilities in this chapter, we'll look at retouching using the Spot Healing Brush and Clone Stamp. These tools have more extensive retouching capabilities than what's available in Camera Raw.

Brushes

In the next section, we'll look at how to selectively apply adjustments using layer masks. A key part of working with layer masks is using the Brush tool. In preparation, let's spend a little time learning about the settings and options for the Brush.

To use the Brush tool, select it in the Toolbox or press B.

To paint with the Brush, click and drag on your photo. This will draw lines of color on your photo, as if you had picked up a marker and were scribbling on a print. When we start using the Brush with layer masks, we won't be literally drawing on a photo, but this description gives you an idea how the Brush works. The color the Brush paints with

is the same as the foreground color (located the bottom of the Toolbox). The background color does not affect the Brush.

Foreground Color

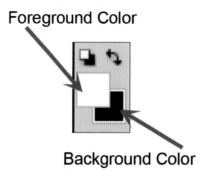

Background Color

If you'd like to create a blank document to practice on, here's what you do:

1. Go to File>New to bring up the New Document dialog box. It's not necessary to give this document a name.

2. Next to the Width and Height values are the units. Click one of the units to change them to inches. Enter a width and height for your document: 6×4 inches works well.

3. For Resolution, select 300 pixels/inch.

4. For Color Mode, choose RGB Color, 8 bit.

5. For Background Contents, choose White.

6. Click OK.

Brush shortcuts

- Press D to return the foreground and background colors to their defaults of black and white. You can also click on the miniature black and white boxes above the Foreground Color box.

- Press X to swap the foreground and background colors. This makes it easy to switch between painting with black and white. You can also click on the curved double arrow above the Foreground Color box.

- Press the left bracket key ([) to decrease Brush size or right bracket key (]) to increase Brush size. This shortcut allows you to change your Brush size without having to move the Brush away from the part of the image you're working on.

- Press Shift-[to soften the Brush or Shift-] to harden the Brush. The Brush hardness is increased or decreased in increments of 25% with each press of the key.

BRUSH TROUBLESHOOTING

Normally, the Brush pointer is a circle, but crosshairs could appear instead for two reasons:

- The Brush is set to a very small size (less than 5). Increase the Brush size (right bracket key) to turn it back into a circle.
- The Caps Lock key has been pressed. Press the Caps Lock key again, and the circle will return.

Brush hardness

The Brush can have a hard edge or soft edge. Click on the Brush Preset Picker in the Options Bar (directly above the photo) to see the Hardness slider.

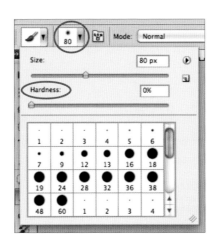

Hardness refers to how fuzzy the edge of the Brush is. Take a look at these three brush strokes.

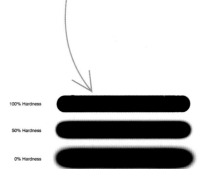

100% Hardness

50% Hardness

0% Hardness

With a soft-edged Brush, the paint along the edges fades away, creating the "soft edge." The reason is that the soft-edged Brush applies the paint at a gradually lower opacity along the edges. I find using a soft-edged Brush makes it easier to blend an effect into part of an image, thereby making it less obvious a change was made. With a hard-edged Brush, there is a clearly defined line between the changed and unchanged areas. Choosing a soft or hard Brush depends on the specific element in the photograph you're working on, but the majority of the time I use a very soft Brush, often at 0% Hardness.

Opacity and Flow are two other important Brush settings. They're found in the Options Bar. They each have a range of 0% to 100%. The default is 100%.

Opacity

Opacity is the transparency of the color you're painting. As you paint over an area (without releasing the mouse button), you're laying down only one layer of color. The transparency of that color matches the Opacity amount. Let's say you're using black: 100% Opacity is black, 75% is dark gray, 50% is middle gray, 25% is light gray, and 0% is white (no paint laid down). The opacity of the paint will not change no matter how many times you paint over the same area. When you lift the mouse button and then go back and paint over the same area, you'll

be painting an additional layer of color (equivalent to the Opacity amount). Just remember that 100% Opacity is opaque (solid color).

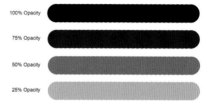

Each line above was a single stroke of the Brush, drawn without lifting the mouse button. Now let's look at building up Opacity. To build Opacity, you need to lift up the mouse button between brush strokes. For the lines below, I set the Opacity to 25%. I went over each line one, two, three, or four times. The more times I went over the line, the darker it became (releasing the mouse button between each stroke).

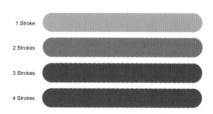

It might seem logical that four strokes, each at 25%, would build up to 100% (25 + 25 + 25 + 25 = 100). You can see from the last set of lines that Opacity doesn't quite work that way. Each stroke does build up the Opacity but not in the exact increments you might think.

I drew the line above to see how many strokes it would take at 25% Opacity to build up to black (100% Opacity). I overlapped each stroke to show the gradual buildup on a single line. It took nine strokes to get to black. What this means is that you should not use Opacity as an absolute value, but as a guide for how slowly or quickly you want to build up the Opacity.

Flow

Flow controls how fast a color is applied as you move the Brush over an area. It is similar to Opacity in that as you paint back and forth, the amount of color will build up

based on the Flow amount (the lower the Flow, the longer it takes the color to build up). Unlike Opacity, however, the amount of color will continue to build as you go back and forth even if you keep the mouse button pressed. Think of it like shading part of a drawing with a pencil. If you lightly move the pencil back and forth, the area will be lightly shaded. But the more you go back and forth over the same area (no matter low lightly), the shaded area will become darker. I always use Flow with a soft-edged Brush because the results are smoother.

Opacity + Flow

Opacity and Flow are not independent of each other. The Flow is limited by the Opacity setting. If you keep the mouse button pressed, the Flow will continue to build up until it reaches the Opacity amount. If the Opacity is 100%, then the Flow will build up to a solid color. Let's say you're painting with black and set the Opacity to 50% and the flow to 10%. If you keep the mouse button pressed each time you paint over the area, the color will

build up in 10% increments (the Flow). Now let's consider the Opacity's role in this situation. No matter how many times you go over the same area, the color will not become darker than middle gray because of the 50% Opacity setting.

Here's another way to think of it: The total amount of color laid down will not exceed 50% because the Opacity won't let it go any higher. If you want the color to become darker than middle gray, you'll need to release the mouse button and then paint again. By doing so, you reset the maximum Opacity to allow you to add another 50%, allowing you to make a darker color.

Practice with the Opacity and Flow settings to get a better feel for what I've described. Start by working with one at a time; then use them both and experiment with different settings. Practicing with a black Brush and a blank white document will make it easy to see how the Brush's functionality changes as you try different settings.

Using layer masks with adjustment layers

As you learned earlier, adjustment layers are important because you can nondestructively enhance your photographs. However, those enhancements affect the entire image. One of the reasons you may have left Camera Raw and brought your image into Photoshop is to apply adjustments that affect only part of your photo. For example, you may not want increased saturation or contrast added to the entire image. Layer masks allow you to selectively apply these adjustments. Let's find out what layer masks are and how to use them.

So what do you do with this layer mask? Well, this is where the Brush tool comes in. You will paint on the layer mask with either black or white. Previously, I mentioned that layer masks allow you to selectively apply the effects of adjustment layers. The Brush color has two basic functions: Black blocks (or hides) the effect of the adjustment layer, and white reveals (or shows) the effect. Layer masks are white by default, which means they automatically allow the adjustment layer to affect the entire image.

Every adjustment layer has a layer mask by default. In the Layers panel, the white box found next to each adjustment layer icon is a layer mask.

These two layer masks show the extremes of what color a layer mask can be. The Vibrance layer mask is white, which means the Vibrance adjustment affects the entire image. The Curves layer mask is black, telling you that no part of the image is affected by the Curves adjustment. It's as though the Curves adjustment layer isn't even there because its effect is completely blocked.

1 Sometimes you'll want the layer mask to stay all white; other times a mix of black and white will be the solution. To paint on a layer mask, first select it by clicking the mask in the Layers panel. You'll know it's selected when you see an outline around the corners of the layer mask. Now select the Brush tool (press B).

2 Press D (to return the foreground and background colors to their defaults); then press X to set your foreground color to black. Click and drag on your photo over the areas where you want to block the effect of the adjustment layer. Although it seems as though you're painting on the photograph, you're actually painting on the mask. When you release your mouse button, you'll see black areas appear on the layer mask in the Layers panel. This shows which parts of the image have been painted with black.

Let's look at how I used a layer mask with this photo.

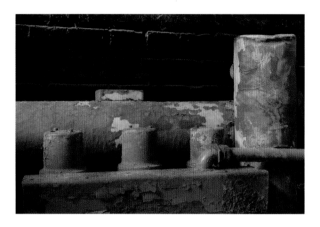 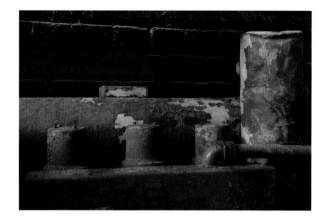

I used a Curves adjustment layer to darken the image.

The Curves adjustment layer has a white mask, which means the darkening effect changes the entire image. I don't want the dark bricks in the background to be further darkened. I'd like them to stay the way they were before I darkened the image.

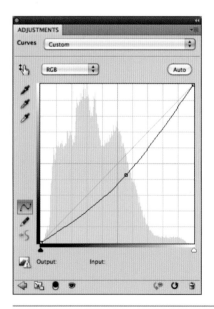

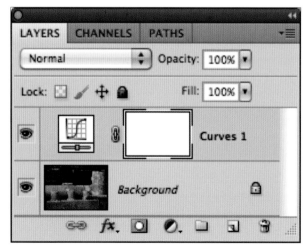

To block the darkening effect on the bricks, I selected the Curves layer mask and then painted over the bricks with black. This brought the bricks back to what they looked like before I darkened the image. On the layer mask, you can see there are now areas of black, showing where I blocked the darkening effect of the Curves adjustment layer.

Layer masks are also very forgiving. Let's say you accidentally paint with black where you don't want to. You could undo (Edit>Undo), but what if you don't realize your mistake right away? You've already done a bunch of other painting, and you don't want to undo all that work. No problem. Just paint with white. That's right; switch your Foreground color to white (press X) and paint over those accidental black brush strokes with white. All gone. You can go back and forth from black to white as much as you want. Image quality is not going to suffer because all you're doing is blocking or showing the effect—on an adjustment layer no less. You're nowhere near touching your actual image!

Painting with white is a convenient way to redo or refine how you've

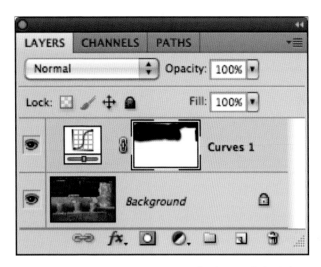

painted on the layer mask. However, if all you have to go on is the tiny layer mask in the Layers panel, it can be difficult to know exactly where to paint. To make life easier, press the Backslash key (\) to show an overlay of the layer mask (the Backslash key is next to the bracket keys). Black areas on the layer mask appear as a red overlay on your image. Now you can see exactly what is black and white on the layer mask. Any area without the red overlay is white.

Use your Brush as you normally would. When you paint with black, you'll add more red overlay. Painting with white removes the red overlay. Having the overlay turned on made it easier for me to see where I was painting with black, and I could more precisely paint along the edges of the pipes.

Be aware that sometimes when you press the Backslash key, the foreground and background colors will switch. Take a look at them before you begin painting, and press X if you need to switch them.

Working with Opacity and Flow

In the "Brushes" section, we learned what the Opacity and Flow settings control. Now let's apply that to working with layer masks. Adjusting Opacity and Flow gives you the flexibility to paint with shades of gray instead of being limited to the extremes of black and white. When you paint with gray, you're blocking part of the full effect of the adjustment layer. When you use a reduced Flow or Opacity, the layer mask will be a mix of white, black, and gray.

When I began experimenting with these settings, I would lower the Opacity of the brush so that I could gradually build up how much I wanted to block or show the effect. This technique worked, but I felt I didn't have as much control as I did when building the effect. When I began to adjust the Flow instead, it quickly became my preferred setting. By choosing a low Flow setting, I can gradually build up (or down)

an effect in a way that feels very natural. My Flow is often less than 10%, usually 5%, 3%, or sometimes even 1%. The setting you should choose depends on how slowly you want to adjust the effect. I prefer Flow instead of Opacity because I can add more paint by continuing to brush back and forth, instead of having to release my mouse button to lay down more paint. As mentioned in the "Brushes" section, I almost always use a soft-edged brush, usually set to 0% Hardness.

Let's continue to work with the pipes photo. I want to add saturation to the purple and yellow paint, but not equally. The yellow paint is already more intense than the purple paint, so I don't want to add as much saturation to the yellow areas. I begin by adding a Hue/Saturation adjustment layer and increasing the saturation until the purple areas look good. Now it's time to paint with black on the Hue/Saturation layer mask to block some of the saturation. Using a black Brush and low Flow amount, I can gradually reduce the amount of saturation in select areas of the photo. The resulting layer mask shows shades of gray instead of pure black.

Selections: Shortcuts to layer masks

The selection tools in Photoshop can be used as a shortcut to creating a layer mask for an adjustment layer. As with many things in Photoshop, there is more than one way to do the same thing. Think of this as simply another option for how to work with a layer mask. If and when you'll use it depends on the image and your personal preference. I'll use the Quick Selection tool to demonstrate the process, but this technique can be used with any selection tool.

When you select something in a photo, it's as though you drew an outline around it. The Quick Selection tool is easy to use and does a great job of making "intelligent" selections. Select the Quick Selection tool in the Toolbox or press the W key.

Your mouse pointer now looks just like it does when you're using the Brush tool (a circle), except it has a plus sign inside it. Think of the Quick Selection tool as a brush for making selections. For that reason I'll make references to brushing with the Quick Selection tool.

Here's an overview of what you're going to do: Step 1: Make a selection; Step 2: Add an adjustment layer.

In the simplest of terms, that's all you're doing, but we'll go through it in more detail. The key point to remember is that you're making the selection first and *then* adding the adjustment layer.

You can use the left and right bracket keys to increase and decrease the size of the Quick Selection tool, just like with the Brush tool.

Continuing to work with the pipes photo, I want to use a Levels adjustment layer that affects only the pipes. Using the Quick Selection tool first will make the process easier. The first step is to select the part(s) of the photo that I want to change with the adjustment layer. I click and drag the Quick Selection brush over part of the area I want to select.

A dotted outline appears around the selected area. This area is larger than where I clicked and dragged because of the "intelligent" nature of the tool. Photoshop analyzes the tones and colors of the places I clicked and dragged and then looks for similar areas nearby and expands the selection to include them. The Quick Selection tool does quite a good job of detecting edges, which helps it accurately outline elements in a photo.

I continue to click and drag across the pipes (avoiding the bricks in the background), and before long, I have all of them neatly selected. The selection outline goes across the tops of the pipes and around the edges of the photo.

In the top-right corner of the photo, the selection went a little beyond the edge of the pipe. If you select something you don't want included (or you just change your mind), you can easily deselect areas of the photo.

To deselect, I press and hold the Option (PC: Alt) key; inside the Quick Selection brush, the plus sign changes to a minus sign. Minus indicates I will be taking away from the selection, not adding to it. With this key held down, I brush over the area I don't want selected, and the dotted line quickly snaps back to the edge of the pipe.

Reduce the size of the Quick Selection tool brush when you want to be more precise with selecting or deselecting.

I continue to refine the selection until everything I want to change with the adjustment layer is selected. Once the selection is finished, it's time to add the adjustment layer. I go to the bottom of the Layers panel and choose a Levels adjustment layer.

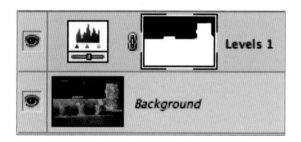

Take a look at the layer mask for the adjustment layer I added. You'll notice that the layer mask is not all white, but a mix of black and white. The black parts are the areas that were *not* selected. And we know that black on a layer mask means the effect is being blocked from those areas.

LAYER MASKS FROM SELECTIONS

Even though you used a selection to create the layer mask, it still works like any other layer mask. You can still paint on the mask with a black or white brush, which means you can refine the layer mask. Sometimes using the selection method will give you the perfect layer mask. Other times you'll want to use the mask as a starting point. Either way, using a selection to make a mask can save you some time.

Selectively lightening and darkening

A common enhancement to photographs is selectively lightening and darkening. That may not sound like much, but these basic tonal adjustments can go a long way toward improving an image. For example, lightening an area draws more attention to it, whereas darkening an area pushes attention away. Photoshop has a couple of tools in the Toolbox for this: Dodge and Burn. Dodge is used for lightening, and Burn is used for darkening. They get their names from the wet darkroom techniques used for the same purposes.

Although these tools enable you to selectively lighten or darken, they are not nondestructive; they don't use masks or adjustment layers. My preferred approach is to use nondestructive adjustments whenever possible because they give me more flexibility in the future. I can always remove a nondestructive adjustment without affecting the quality of the photograph.

Instead of using the Dodge and Burn tools, we'll look at how to achieve the same results nondestructively by using layers. Begin by adding a new layer. Go to Layer > New > Layer.

In the New Layer dialog box, do the following:
- Give the layer a name, such as Lighten/Darken or Dodge/Burn.
- For the Mode option, choose Soft Light from the pop-up menu.

Click OK, and a new layer is added in the Layers panel. The layer thumbnail has a checkerboard pattern indicating it is transparent; there's nothing on the layer, and at this point, it doesn't have any effect on the photo. Everything is now set to begin the selective lightening and darkening.

The next step is to select the Brush tool and then paint on the photo with black or white. Black will darken and white will lighten. There is no layer mask involved; you're working directly on the Lighten/Darken layer. Compare the before and after versions of this image. The selective adjustments were used to darken the trees, plus lighten the rocks and the water.

The Lighten/Darken layer now has patches of darker gray and lighter gray from where it's been painted with black and white. If you lighten or darken too much, it's an easy fix. If you make an area too dark, all you need to do is paint with a white brush to lighten it. If an area becomes too light, paint with black to darken it. You can go back and forth with black and white as much as you want—just like a layer mask.

The little gray areas on the Lighten/Darken layer can be hard to see as they blend in with the checkerboard pattern. To see better where you painted on the layer, click the Eye icon next to the Background layer. This hides the Background layer, making the photo disappear; all that's visible is the actual Lighten/Darken layer. Click the Eye again to bring back the photo.

If you change your mind and don't want the lightening/darkening applied to some part of the photo, you can remove the effect with the Eraser tool. Select the Eraser in the Toolbox or press the E key. Then make sure you have the Lighten/Darken layer selected. Click and drag over the area(s) where you want to remove the effect. This erases any color, returning it to transparent.

All in all, the selective lightening/ darkening process is very flexible; plus it's nondestructive because you're not changing the original photo. At any time you can delete the Lighten/Darken layer, and all its effects will disappear.

CONTROL THE LIGHTENING OR DARKENING

Painting with pure black or white will result in significant lightening or darkening, probably more than you'd like. To control the strength of the lightening or darkening, reduce the Brush's Opacity and/or Flow settings (found in the Options Bar). Try starting around 10%. The lower the setting, the weaker the initial effect of the brush will be; you can then gradually build up the effect to the amount you want.

Retouching

When you need to do retouching that's beyond the capabilities of the healing and cloning tools in Camera Raw, bring your image into Photoshop to get the job done. Next, we'll look at the Spot Healing Brush and the Clone Stamp.

Spot Healing Brush

The Spot Healing Brush is great for cleaning up sensor spots, skin blemishes, and other small areas of imperfections. Begin by selecting the Spot Healing Brush in the Toolbox or press the J key.

In the Options Bar, choose Content Aware if you're using CS5; choose Proximity Match for CS4 and earlier. Also, if using Content Aware doesn't produce good results, try using Proximity Match as well.

As the name suggests, you're using a brush with this tool. This means you can change the brush size using the bracket keys, just like with the Brush tool. To get rid of a spot or other small element, choose a brush size that's a little larger than what you want to remove in your photo. Then just click on the spot, and it's gone.

To remove these small water drops, I clicked on each one with the Spot Healing Brush, adjusting the size to fit the droplet.

How does the spot healing brush do its magic?

Photoshop samples the colors and textures surrounding the area where you click. Then it creates a blend of those colors/textures. That "blend" is placed on the spot where you clicked, making the unwanted element disappear.

Next, let's look at removing a larger element with the Spot Healing Brush. To retouch larger areas, you click and drag across the element to be removed. Be aware that the larger the area you try to retouch in one brush stroke, the more likely there are to be problems. For larger or more extensive retouching work, you may get better results using the Clone Stamp, discussed in the next section.

1 I want to remove the crack in this photo. Instead of clicking a single spot, I click and drag down the crack to brush over the entire crack in one stroke.

2 The first attempt wasn't such a magic fix. It removed the crack but left behind obvious artifacts (unwanted tones and textures). I went to Edit > Undo and then tried again.

3

For my second attempt, I started my click and drag a little lower, and it yielded much better results. If you're getting artifacts, also try changing the brush size. An unnecessarily large brush can cause Photoshop to sample too much around where you clicked. A smaller brush can better "focus" Photoshop on what you want removed.

1

In this photograph of a spider, I want to clone away the out-of-focus piece of grass sticking in the left side. I tried the Spot Healing Brush, but the results weren't ideal. I begin by selecting the Clone Stamp in the Toolbox (or press the S key).

Clone Stamp

The Clone Stamp is suited for more extensive retouching. You have greater control over what areas are copied (cloned), compared to the Spot Healing Brush's automated method. The Clone Stamp is also applied with a brush. In most cases you are not trying to clone something in one single click with a big brush. You should use a series of single clicks or small click-and-drag procedures.

2

To use the Clone Stamp, you first need to set the source. The source is the place where the Clone Stamp will copy from. To set the source, hold down the Option (PC: Alt) key. The brush will change to a bull's-eye symbol. Move the bull's-eye to where you want the source to begin and then click once.

3

I set my source as the green area just above the left end of the grass. I picked an area close to the grass so the cloned area blended with the surrounding colors and tones. If I chose a source too high or too low, the green wouldn't match and the cloned area would stand out.

When you're using the Clone Stamp, the source does not stay locked in place; it moves with the brush. For more extensive cloning jobs, it can be helpful to change the size of the brush and select new sources as you go. This will produce better quality results and reduce the likelihood of unwanted artifacts.

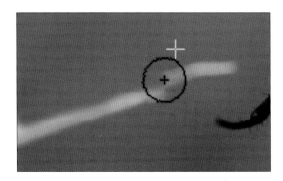

I started cloning by brushing along the top edge of the grass with a combination of single clicks and short strokes. I wasn't trying to remove the whole section of grass at once. The large white plus sign that appears outside the brush tells you where the source is. As I mentioned earlier, the source does not stay locked in one place but follows along as you move the brush.

Keep an eye on the location of the source to make sure you're cloning from the right area. You might need to stop and choose a new source as you're cloning.

5

After I removed the top half of the grass, I went back and did a second sweep to clone out the rest.

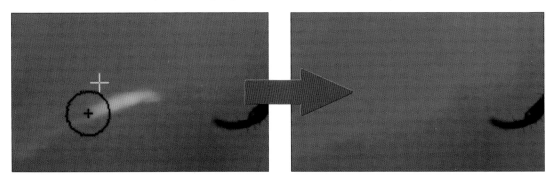

Look for any imperfections (artifacts) that give away that you cloned something out of the image. These can be repeating small bits of color or just individual areas that don't blend with the surrounding tones or colors. You can use the Clone Stamp to go back and spot-fix these areas. The Spot Healing Brush also works well for post-cloning touch-up. In the finished photo, nothing should look unnatural or out of place.

File saving and file formats

At this point, you've worked on your photo in Camera Raw and Photoshop, and it's looking good! Now that we've applied global adjustments plus local fine-tuning, this brings us to the end of adjusting and enhancing photographs. The next steps in the photographic workflow will be about what you want to do with your photographs: How do you want to share them and get them out in the world? The next chapter will go over a variety of options. Let's wrap up this chapter with some thoughts about saving files.

After you've done all that work in Photoshop, of course, you want to be sure to save your file. But what about the various file formats to choose from? I recommend saving files in a TIFF or Photoshop (called PSD) format. JPEG is another, more common, file format, but I prefer not to use JPEGs at this stage for a couple of reasons. First, JPEGs are compressed files, and compression can affect the quality of the image. TIFFs and PSDs are not compressed, which also means they are larger files that take up more space on your hard drive, but the trade-off is worth it. Second, JPEGs cannot have multiple layers. All the layers have to be combined

into a single Background layer if you want to save a photo as a JPEG. This means you can't revisit your individual layers (such as adjustment layers) because they will no longer exist after a file is saved as a JPEG. Even if you have only one layer, I still recommend using TIFF or PSD because these formats are not compressed.

You might be thinking these TIFF or PSD files sound great, but if the files are so big, you won't be able to use them for email or web galleries or Facebook. Not to worry! There are features in Bridge that will take care of creating smaller files just for these purposes. All this will be covered in the next chapter.

FLATTEN A PHOTO

If you ever need to have a photo with just one layer instead of multiple layers, you have to "flatten" the image. Flattening combines all the layers into a single Background layer. It does not remove the effects of the layers; a flattened photo will look the same as before it was flattened. To use this feature, go to Layer>Flatten Image (all the way at the bottom).

To save your file, go to File>Save to bring up the Save dialog box.

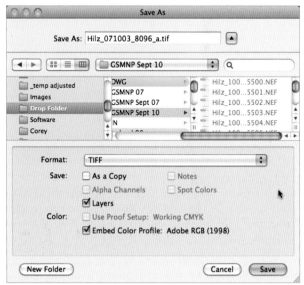

2

Enter a filename. The filename of the original photo will appear by default. To differentiate files I've worked on in Photoshop from the originals, I add a letter or short word to the end. For example, I use *a* or *adj* for "adjusted" or *edit*.

Save As: Hilz_100604_9393_a.tif

3

Choose where to save the file on your computer. I recommend saving it in the same folder as the original photo, which will make it easier to find in Bridge. Also, back in Bridge, you could stack the two files together for easier organization.

For the Format option, choose TIFF or Photoshop. Leave the boxes for Layers and Embed Color Profile checked. Then click Save and you're all set.

Chapter 7: Sharing Your Images: Exporting Photos, Slide Shows, Web Galleries, and PDFs

WE'VE NOW REACHED THE FINAL STAGES of working with our photographs. In this chapter we'll look at various exporting and output options. After you've finished adjusting your photos in Camera Raw and Photoshop, you may be thinking, "What should I do with them now?" Through Bridge, you have a whole range of options: export photos for email, upload them to online social networking sites such as Facebook or Flickr, design slide shows, create web galleries, and more. You may find that the image adjustment process was just the beginning!

Exporting

Using the Export panel in Bridge, you can save JPEG copies of your photos on your hard drive, as well as upload photos to Facebook and Flickr. To use any of the export methods listed, begin by selecting the photos you want to export and dragging them to the name of the export method (Facebook, Flickr, and so on).

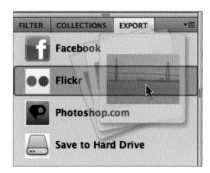

Next, choose the settings for the exporting method. Double-click the name of the export method (such as Facebook), which brings up the Export window. At the top of the window are two tabs: Destination and Image Options. The settings in the Destination tab are specific to the place where the photos are being exported. The Image Options tab has the same settings for any type of exporting.

Facebook and Flickr

The process for uploading photos to Facebook and Flickr are similar, so I'll describe them both here. Before using either option, you will need to have a Facebook and/or Flickr account. If you don't have an account, go to the Facebook or Flickr websites and sign up; then come back to Bridge.

When you use the Facebook or Flickr exporting for the first time, you'll need to sign in to your account and authorize Bridge to upload photos. Click the Sign In button, which will launch your browser and take you to Facebook or Flickr. Click OK to approve the authorization in Facebook or Flickr and then return to Bridge.

Destination tab

When you're logged in, you'll see a list of existing albums/sets that you can choose to add the photos to. For Facebook, you also have the option to create a new album. With Flickr, you have to add the photos to an existing set.

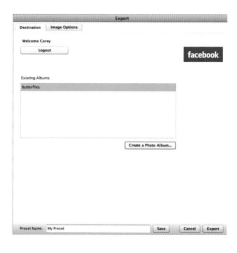

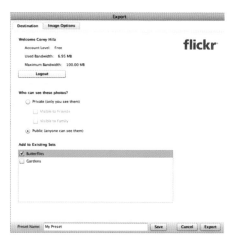

Image Options tab

The settings are the same for Facebook and Flickr. Bridge will export JPEG versions of your photo. On the Image Options tab, you choose the settings for those photos.

Image size and quality

* You can leave the photos at full size or manually choose a smaller size. If you don't want full-size photos, check the box for Constrain to Fit; then enter the length of the longest side (in pixels). For Flickr, you may want to upload the full-size image because Flickr can offer multiple sizes for people to view the photo. With Facebook, on the other hand, photos are just shown at one size, so I recommend constraining the photo to 600–900 pixels.

* For the Resample Method, choose Bicubic Sharper.

* Check the box for Always Render from Fullsize Image; this will give you the best quality.

* For Image Quality, choose 8 and High.

Metadata

You also have control over how much metadata is included with your photos. You can have no metadata, you can limit the metadata, or you can add new metadata.

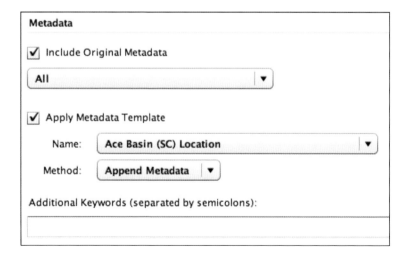

If you don't want any metadata included, uncheck the box for Include Original Metadata. The drop-down menu below Include Original Metadata gives you options for limiting the amount of metadata included.

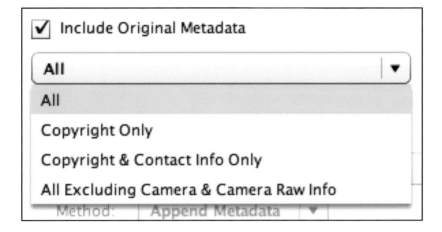

At the bottom of the Metadata section, you can choose to have metadata added from an existing template, as well as type in keywords to be added. Remember that the template metadata and keywords will be applied to all the photos you're uploading.

After you've made all your selections for the Destination and Image Options, click Export at the bottom of the window. A new window will pop up showing you the status of the photos being uploaded.

Save to Hard Drive

The process for saving copies of your photos to your hard drive is similar to uploading for Facebook and Flickr. Again, you're saving JPEG copies of your photos. This is a convenient way to prepare a group of photos that you want to email to someone. Begin by dragging photos to the Save to Hard Drive item in the Export panel. Then double-click Save to Hard Drive to bring up the options.

In the Destination tab, you choose where you want the JPEG copies saved. They can be saved to the same location as the original file or to a different folder. You can also create a subfolder for the JPEGs.

Location

○ Export to Original File Location

◉ Export to Specific Folder:

[**Browse...**] /Users/corey/Desktop

☐ Save to Subfolder Named [_____]

Handle Existing Files By [**Create Unique File Name** ▼]

The settings in the Image Options tab are exactly the same as the ones for Facebook and Flickr. For details about these settings, see the previous section on Facebook and Flickr. After making all your selections, click the Export button, and copies of the photos will be saved to the selected destination.

Presets

If you're regularly using the same settings for uploading to Flickr and Facebook or saving to your hard drive, you can create a preset to save time.

Click the item in the Export panel for which you want to create a preset (Facebook, Flickr, and so on). At the bottom of the Export panel, you can see Preset, and to the right is a plus sign. Click the plus sign to add a preset.

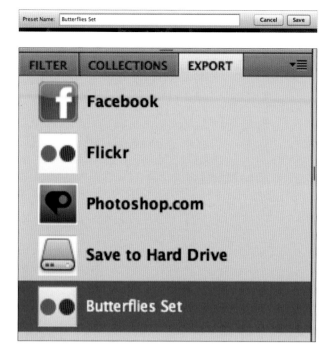

2

A familiar-looking window will pop up; it looks much like the Export window. The Add Preset window has the same Destination and Image Options tabs discussed earlier in this section. Here, you set the options specifically for the preset. After you've made all your choices, go to the bottom of the window, give the preset a descriptive name, and click Save. The preset will now be listed in the Export panel.

3

To use the preset, first drag and drop photos on the preset name. When photos are added to the preset, you'll see a few symbols appear next to the preset:

- Click the arrow on the left to show or hide the list of the photos added to the preset.
- Click the X to remove the photos from the preset.
- Click the arrow on the right to export the photos.

To edit or delete a preset, select the preset and then go to the bottom of the Export panel where it says Presets. Click the pencil to edit or the trashcan to delete.

Slide shows

Bridge makes it quick and easy to create a slide show. Begin by finding the folder that has the photos you want to use in your slide show. You'll use the thumbnails in the Content panel to determine which photos are included in the slide show.

There are a handful of options for the slide show. Go to View>Slideshow Options to bring them up:

- **Display Options:** Darken a second monitor; Set the slide show to repeat; Have the photo zoom in or out and slide around (aka the "Ken Burns Effect").

SLIDE SHOW TIPS

- If you have a single photo selected in the Content panel, the slide show will begin with that photo and then go through the following photos until it reaches the last photo in the folder. If you have the slide show set to Repeat, it'll then go to the first photo in the folder and continue.

- The slide show plays the photos in the same order in which the thumbnails are displayed.

- If you select multiple photos and then begin the slide show, it will include only the selected images.

- To begin the slide show, go to View>Slideshow.

- **Slide Options:** Choose the duration and whether you want to display a caption (shows the file name, rating, and label). The last set of options controls how large the photo appears on the screen.

- *Center:* Photo is on a gray background. Image is a little smaller than the size of the monitor, so there is always a border between the photo and the edge of the screen.

- *Scaled to Fit:* The photo is made as large as possible while still showing the entire image. On most monitors, this means the photo will touch the top and bottom of the screen with a gray backdrop framing the sides of the image.

- *Scaled to Fill:* The photo fills the entire screen but cuts off part of the image to do so (most likely the top and bottom).

- **Transition Options:** Choose the effect that occurs when switching photos. Dissolve is a commonly used transition that creates a smooth shift between images but doesn't draw too much attention to itself. Then choose how fast you want the selected transition to be.

After choosing your options, click Done to close the window or click Play to begin the slide show.

Web galleries and PDFs

In Bridge you can also create web galleries and PDF files for sharing your photos. Both are created using the Output panel. The easiest way to use the Output panel is to switch to the Output Workspace. Click on Output in the list of workspaces at the top of the Bridge window or go to Window>Workspace>Output.

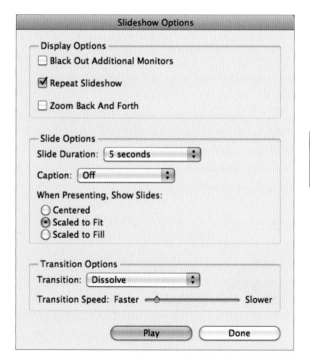

In the Output Workspace, the Output panel is on the right, and in the center are the Content and Preview panels (thumbnails and the selected images). Because this is the same layout whether you are creating a web gallery or PDF, I'll focus on the particular settings in the Output panel. Choose what you want to create by clicking either the PDF or Web Gallery button at the top of the Output panel.

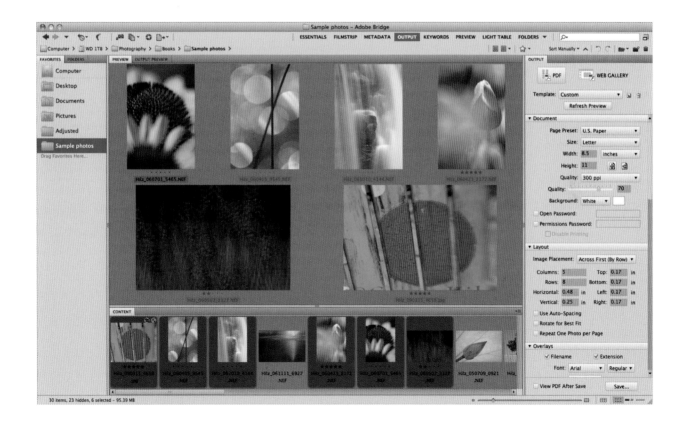

Web gallery

Creating a web gallery in Bridge gives you many layout and design options for customizing the look of your gallery. Begin by selecting the thumbnails in the Content panel that you want to include in the gallery. Don't worry; you're not stuck with what you pick initially. You can select more photos or deselect photos at any time.

As you change the settings in the Output panel, you'll want to be able to preview the layout. At the top of the Output panel is a Refresh Preview button. Click it, and a new panel named Output Preview will pop up. When you make any changes to the web gallery settings (including selecting or deselecting photos), you'll need to click Refresh Preview to see the changes. The Output Preview does not update automatically.

Decide on the template you're going to use before getting into the various settings. At the top of the Output panel is a pop-up menu for the templates.

The template you choose dictates what options are available in the Style pop-up menu (below Template). Some templates have multiple styles; others just have one. Use the Refresh Preview to help you decide which template to use. Select a template, click Refresh Preview, and check out the layout/design of the gallery. Then repeat the process for other templates (choose a template; click Refresh Preview).

The web gallery previews provide more than just a layout to look at. They're fully functional, which means you can test the gallery's functionality and navigation. Click on the thumbnails, buttons, and whatever else the template

offers. Give it a test run. If you'd rather see the gallery in a browser instead of previewing it in Bridge, click the Preview in Browser button (next to the Refresh Preview button). Bridge will launch your default web browser and show you the web gallery. The browser preview gives you a true sense of how the gallery will look after you upload it and someone is viewing it online.

After you've settled on a template and style, you're ready to explore the rest of the settings in the Output panel. There are four primary groups of settings: Site Info, Color Palette, Appearance, and Create Gallery. These groups appear

for all the templates. There are two additional groups, Image Info and Output Settings, which appear when you choose one of the templates whose name begins with "Airtight." I'm going to focus on the four main groups of settings.

All the settings may not be apparent at first because you need to use the scroll bar on the right side of the Output panel to see the full list of settings. Alternatively, if you click the name of a settings group (Site Info, Color Palette, and so on), it will close the group, making room to show more of the lower groups. Click the group name again to reopen it.

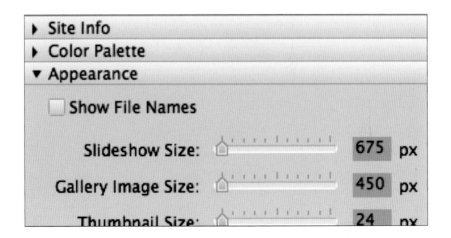

Site Info

The Site Info section provides text information that's displayed in specific locations in the web gallery layout. These text fields are automatically filled with default text. Simply replace what's there with your own information. There is some variation in the text fields (and where they appear in the layout) depending on the template selected.

Color Palette

In the Color Palette section, you can customize the colors used for your gallery. To change a color, click the color box next to the item you want to change. This brings up a window where you can choose a new color. If you're not sure what an item refers to in your gallery, change the color and then click Refresh Preview and look for what changes in the gallery. The amount of color customization available depends on the template you're using.

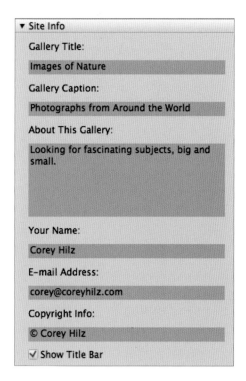

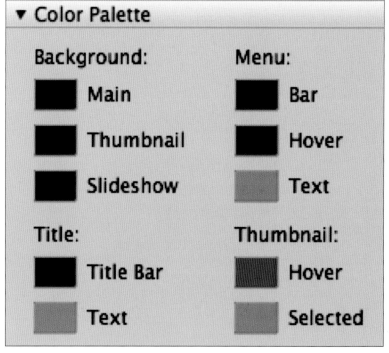

Appearance

You can change the options for how the photos and text are displayed in the Appearance section. Many of the options are related to photo size because the photos are used in multiple capacities in the gallery (thumbnails, regular gallery images, slide show images). The exact options available depend on the template selected.

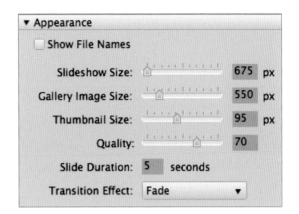

Fine-tune your web gallery by experimenting with the various settings, remembering to click the Refresh Preview button frequently so you have an accurate view of how it will look.

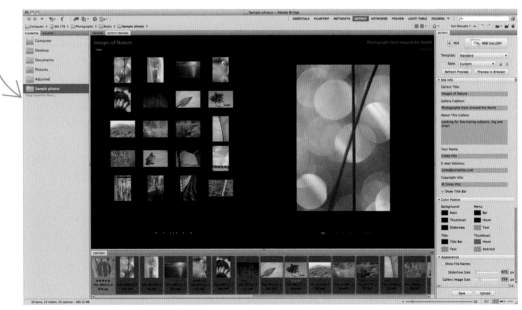

Create Gallery

When you are done choosing all the layout and design options for the gallery, one of the last steps is to choose how you are going to publish your gallery in the Create Gallery section. Your options are to save the web gallery files on your computer (Save Location) or have them automatically uploaded to a server (Upload Location). For both options, Bridge will create copies of the photos, resize them, and write the HTML code to produce the web gallery pages. If you choose Save Location, you're left with a folder that contains all the necessary files for the web gallery. You'll

Using the Save Location option in the Create Gallery section simplifies things because Bridge takes care of the uploading for you, accessing the FTP Server using the information you enter in this section.

need to manually upload the folder to your website (outside Bridge), and then people can view your gallery online.

After you've entered the information for Save Location or Upload Location, go to the bottom of the Output panel and click the Save or Upload button (depending on which option you chose in the Create Gallery section). These buttons are always visible; you don't need to scroll down to see them.

Whether you are saving the files or uploading them through Bridge, it's always a good idea to view your gallery online and make sure it looks as you expected.

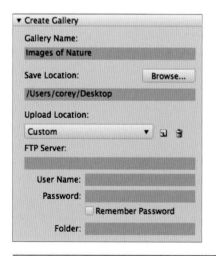

PDF

When creating a PDF, you're designing a layout for one or more photos on a piece of paper. PDF refers to the file format that will be used when you save the layout. The photos are laid out based on a grid, whether it's for one photo or 20. A common use is for creating a contact sheet that is a page of image thumbnails, sometimes with information below each photo. Contact sheets are generally used as a way to show someone a number of photos for review at once, when large, high-quality versions of the images are not necessary. The number of columns and rows in the grid layout dictates how large each image can be. That being said, contact sheets are not the only use for the PDF layout feature. As you'll see with the templates, you can get pretty creative with the layout options.

Begin by selecting the thumbnails in the Content panel that you want to use in the PDF. Don't worry; you're not stuck with what you pick initially. You can select more photos or deselect photos at any time.

As you change the settings in the Output panel, you'll want to be able to preview the layout. At

the top of the Output panel is a Refresh Preview button. Click it, and a new panel named Output Preview will pop up. When you make any changes to the PDF settings (including selecting or deselecting photos), you'll need to click Refresh Preview to see the changes. The Output Preview does not update automatically.

Now let's look at the many settings you can use. There are seven groups of settings: Document,

Layout, Overlays, Header, Footer, Playback, and Watermark. All these settings may not be apparent at first because you need to use the scroll bar on the right side of the Output panel to see the full list of settings. Alternatively, if you click the name of a settings group (Document, Layout, and so on), it will close the group, making room to show more of the lower groups. Click the group name again to reopen it.

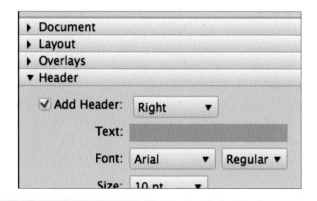

To see what's possible with the PDF options, choose a preset template from the Template menu at the top of the panel. Then click Refresh Preview to see how it arranges your selected photos. If you change any settings, the template name will change to Custom because it no longer matches the template specifications.

Document

Choose the size of the paper, the image quality, and the background color (paper color around the photos). For Quality, use 300 ppi if the PDF will be printed or 130 ppi if it will only be viewed on a computer. A good value for the Quality slider is 80. For increased security, you can require a password to open the PDF.

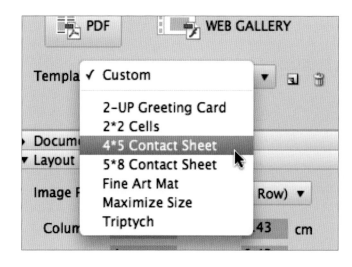

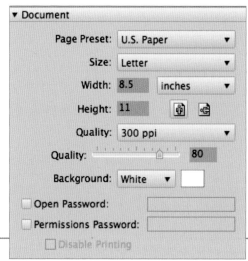

Layout

The Layout settings control the grid layout for your photos. Select the number of columns and rows along with spacing between and around them.

Overlays

You have the option to include the filename under each photo (with or without the file extension). You can set the font, size, and color of the text. You also have the option to display page numbers in the Header or Footer.

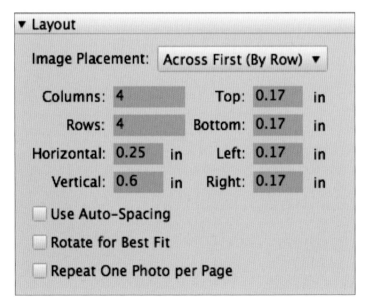

Header and Footer

The Header and Footer groups have the same settings. The header is a section of text across the top of the page; the footer is text across the bottom. The same header and footer information will appear on each page of the PDF. You could use the Header and Footer space to include information such as a title or description for PDF, as well as your name, website, and contact info.

Playback

The Playback options turn your PDF into a slide show. Think of each page in your PDF as a slide. You can set the PDF to automatically go to the next page so the viewer can just sit back and watch. If you set up the Layout options so there is only one photo per page, the PDF would be just like showing someone a slide show. Having the "slide show" in a PDF format allows you to send it to someone and you don't have to be there to run the slide show.

Watermark

When you add a watermark, a line of text or an image is placed on each page. Watermarks are often a copyright notice (for example, © Corey Hilz). An image watermark could also be a logo. If you check Place on Each Image, the watermark is added to each thumbnail; otherwise, it appears only once per page. The options at the bottom of the Watermark section allow you to precisely control where the watermark appears on each image or page. You'll usually want to reduce the Opacity (50% or less), so the watermark is a little faded and doesn't draw too much attention to itself.

When you've finished designing your PDF, go to the bottom of the Output panel and click the Save button. The Save button is always visible, so you don't need to scroll down to see it. Give the PDF a name and choose where you want to save it.

Refine your PDF by experimenting with these various settings, remembering to click the Refresh Preview button frequently so you have an accurate view of how it will look.

Conclusion

When you look at all the ways Bridge can help you share your photos—social networking, slide shows, web galleries, PDFs—you realize just how much is packed into this program. Pick the best methods for you to share your photos with friends and family and have fun getting your photos out there. If you'd also like to be able to print your work, perhaps to hang on your wall or give as a gift, check out the next chapter, where we go through the printing process from start to finish.

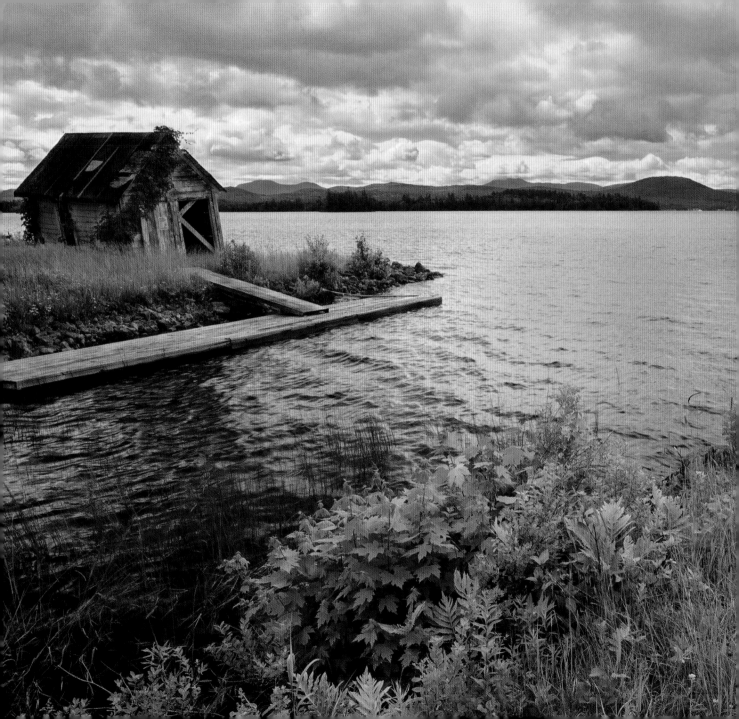

Chapter 8: Printing

PRINTING YOUR OWN WORK CAN be a gratifying experience. You captured the image, you adjusted it, and now you're able to watch your masterpiece roll out of your printer. The challenge when printing your own work is producing a print that looks like what you see on your monitor. The steps we'll go through in this chapter will help you achieve more consistent printing results, which will save you time, paper, and ink. An important step to take before you even go into Photoshop or Bridge is calibrating your monitor. You need a separate piece of hardware to do this, and there are a number of companies that make monitor calibration devices. Here are a few to consider: Datacolor's Spyder; Pantone's ColorMunki or Huey; X-Rite's Eye-One Display. If you calibrate your monitor using the software that comes with the device, you can be more confident in the accuracy of the colors on your screen.

Also useful in the printing process are printer profiles, also called *ICC profiles*. These files tell Photoshop how to adjust colors for a specific printer/paper combination. Profiles for the printer manufacturer's own paper are often installed automatically when you initially set up your printer (for example, Epson printer and Epson brand paper). If you're not sure whether you have printer profiles (or if they're available), check with the manufacturer of the paper you use. The manufacturer would be the one to supply the printer profiles. In the steps here, I will be using printer profiles. They are important for on-screen proofing as well as the printing process.

Here's a summary of the printing preparation process: Use on-screen proofing to preview how the printer will reproduce the image, make adjustments to "fix" the shifts seen during proofing, flatten the image, resize, sharpen, and then print.

1

Open a photo in Photoshop; this can be done from the Camera Raw window or straight from Bridge. At this point the photo should be in its finished form. You don't need to make any further adjustments other than those needed to produce a print that looks like the image on your monitor.

2

Go to Image > Duplicate. In the dialog box that pops up, leave the filename as is; then click OK.

Duplicate Image	
Duplicate: Hilz_090331_5967a.tif	OK
As: Hilz_090331_5967a copy	Cancel
☐ Duplicate Merged Layers Only	

3

Flatten the duplicate photo if it has more than one layer (Layer > Flatten Image). Because you've already done the general image adjustments, you don't need the separate layers. This also keeps things simpler when you add adjustments during the proofing process.

4

Save the duplicated image (File > Save). The duplicated image will be the one you adjust for printing. When you keep a separate file for printing, your original (master) image remains unchanged. When naming my files for printing, I add an underscore and a capital *P* to the end of the original filename. This naming convention lets me know which master file it's from, and the *P* designates it as a file

prepped for printing. I like to keep all my printing files in a separate folder from the master files.

 You should now have two windows with identical images. For the next steps, you'll need to be able to see both photos at once. If you can't see both photos, go to Window > Arrange > Float All in Windows.

 When you can see both windows, click and drag to move them around so there is little or no overlap. If you need to increase or decrease the size of the photos to do this, use the keyboard shortcut Command-plus (+) (PC: Control) or Command-minus (-) (PC: Control). If the photos are overlapping, make sure the duplicated photo is on top. Because the photos are identical, look at the filename across the top of the window to know which is which. For my files, the filename with "_P" at the end is the duplicate. The purpose of having two windows with the same photo is to have a reference image when you make adjustments for printing. One photo will remain untouched, and the other will be fine-tuned in preparation for printing.

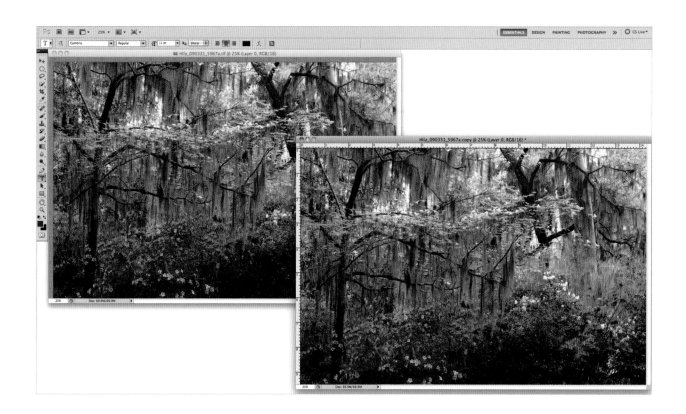

7

Set up a proof view. Go to View > Proof Setup > Customize. In the Proof Setup window, there are three options you need to set: Device to Simulate,

Rendering Intent, and Black Point Compensation.

- **Device to Simulate:** Choose the printer profile (ICC profile) for the printer/paper combination you're

using. Do not check Preserve RGB Numbers.

- **Rendering Intent:** Select Relative Colorimetric. Check Black Point Compensation.

Save the settings so you're able to reuse them. Click Save and then give the proof view a descriptive name so you know what paper/printer combo it's used for. Don't change the location where's it's going to be saved. Photoshop has automatically selected the appropriate folder. After you save it, click OK in the Proof Setup window to return to your photo.

Make sure the printing version (the duplicate you made) is the selected window. If your two windows overlap, the window on top is the selected one. Another way to check which is the selected window is to go to the Window menu. At the bottom of the menu are the names of the open files. The selected file has a checkmark next to it. To select the other photo, simply click its filename.

Turn on the proof view. Go to View > Proof Setup; then choose the name of the proof view you just saved. The appearance of the selected photo (step 9) will shift; how much of a change you see depends on the colors in your photo and the printer profile you're using. The proof view is a preview of what your photo would look like if you printed it right now.

To double-check that the proof view is on, make sure the name of the printer profile being used is displayed at the far right of the information in the title bar. For my photo, the printer profile is named Pro38 PLPP.

11

Now you're set up with two windows: One is what your print *will* look like (proof view), and the second represents what you *want* your print to look like (master image). For this step, your goal is to make adjustments to the proof photo to make it match the master image. Remember to use nondestructive adjustments, such as adjustment layers, as discussed in Chapters 5 and 6. Common shifts seen in the proof view are reduced contrast (the image may look "flat") and colors looking less intense. Standard adjustments I make to remedy these problems are Hue/Saturation and Curves. A saturation boost of 10–15 improves the intensity of the colors. A slight S-shape in Curves can bring back the lost contrast. Be careful not to overdo your changes because you're just working to get the proof image to match the master image. These are just a couple of suggestions; what you need to do to match the images may vary. When you have the two images as close as possible, go to the next step.

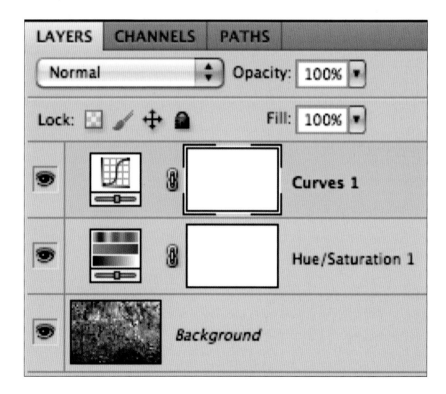

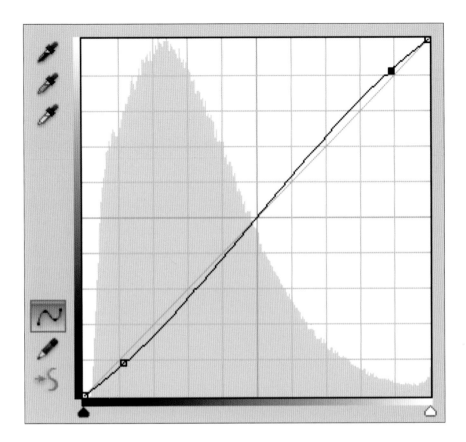

Now you've got the colors and tones of the proof image looking good. However, as helpful as the proof view is, you should make sure the print is going to come out as you expect. There is more to be done,

including resizing and sharpening, but this is a good time to stop and make a proof print to see how things are going. There's no need to go through all the remaining steps and then make a print only to find out the colors aren't correct. You'd just have to backtrack and adjust the photo. Let's try to avoid that.

Go to File > Print. The options/settings you use in the print dialog are almost identical to what you'll use when making your final print. When it's time to make that final print, you can refer back to these next steps.

Later when you click the Print button in the main Print window, another window should appear, giving you access to the Printer Settings. Also, the Printer Settings will vary depending on the printer you're using. The screen shot below is for an Epson printer.

No matter which printer you're using, here are the key settings to look for:

- **Media Type (paper):** Choose the type of paper you are using (matte, luster, glossy, and so on).

- **Color Mode:** Set to Off. This option may also be referred to as Color Management. What you're doing here is turning off the printer's control over the color. This is critical because it's what allows Photoshop to control the colors in the print.

- **Resolution:** Using 1440 dpi is adequate. A higher resolution could be used for finely detailed photos, but it will take longer to print.

- **High Speed:** This setting prints out your image faster. This is okay for proof prints. However, it can

13

Print Settings is just a single button in the Print dialog, but it holds a lot of settings that are important to preparing a good print. The key settings in the Print Settings window are Printer, Paper Size, and Printer Settings.

- **Printer:** Choose the printer you're using (the printer should be turned on).

- **Paper Size:** Select the paper size you're printing on. To save on paper and ink costs, print proofs on a small paper size, such as 4 × 6 inches.

- **Printer Settings:** Where you find the printer settings in the window depends on your operating system. The settings may be listed within one of the pop-up menus. If you can't find them, don't worry; continue with the rest of the steps.

affect print quality on some printers, so I suggest doing a test print before using High Speed for your final print.

Click Save when you're done, and you'll return to the main Print window.

Back in the Print window, let's look at what's in the left side of the window. The image is a preview of what will be printed. As you change settings in this window, such as print settings, scaled print size, and printer profile, the preview's appearance will change. The checkboxes below the image are display options for the preview image; they don't affect how the photo will print.

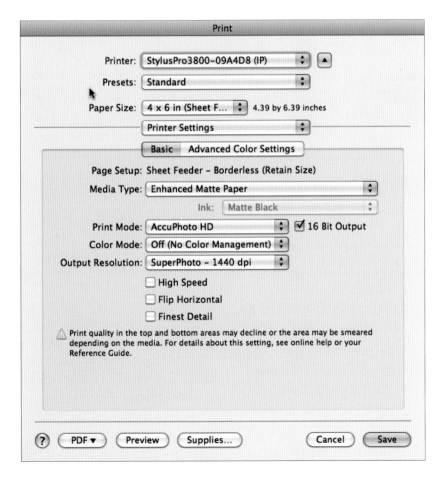

- **Match Print Colors:** The preview will look like your proof image.

- **Gamut Warning:** The colors in the photo that are out of gamut will turn gray. Out of gamut means the printer is not able to correctly print these colors; they're out of the range of what the printer is able to reproduce. This does not mean the colors won't print at all, just that they may not come out exactly as you see them on your monitor. Because they represent possible problem areas, pay attention to the out-of-gamut areas when reviewing your proof.

The image on the right has the Gamut Warning turned on. Notice some of the pink azaleas in the bottom right have turned gray.

- **Show Paper White:** This option simulates what pure white areas in your image will look like based on the printer profile selected. Pure white means there is no detail or color, so no ink is put down; you're actually seeing the paper.

Next, move on to the settings down the middle:

- **Printer:** This option will automatically change to match the printer chosen in the Print Settings.

- **Orientation:** The paper will go in the printer vertically, but here you choose whether the photo itself is a portrait or landscape orientation.

- **16-bit data:** If your photo is in 16-bit mode, check this box.

- **Position:** Check the box for Center Image.

- **Scaled Print Size:** Because this is a proof print, you don't need to resize the photo. If you're doing a small proof, then the actual photo size will be way too big. Check the box to scale down the photo to the paper size you selected in the Print Settings. Alternatively, you can adjust the scale, height, and width to set the print size more precisely.

- **Document vs. Proof:** Click the button next to Document.

- **Color Handling:** Select Photoshop Manages Colors.

- **Printer Profile:** Choose the profile for the printer/paper combination you're using.

- **Rendering Intent:** Select Relative Colorimetric.

- **Black Point Compensation:** Check the box.

To finish up in the Print window, let's go to the settings on the right. Some of these are the same as what you chose when creating the proof view.

You're ready to print your proof. Click the Print button and let your printer go to work. Evaluate the proof to see how close it is to what you see on the monitor. This proof is for evaluating colors and tones; you have not done any sharpening yet. The type of lighting under which you view your print will influence how you perceive the colors. For example, looking at your photo under a tungsten/incandescent light will make it appear much warmer than it actually is. Diffused window light is a good light source, as are lamps with full-spectrum daylight-balanced light bulbs. If your photo does not match what you see on your monitor, it's time to revisit the proof and make additional image adjustments.

Repeat steps 11–16 until you are satisfied with the colors/tones in your proof print. When you print additional proofs, most settings in the Print window should remain set to what you last used. Double-check everything to be sure, but you likely won't have to select all the settings again.

18

Now that the colors and tones in your photo are ready for printing, you can begin preparations to produce a print of a specific size. In my printing workflow, I like to be able to go back and reuse the same photo for prints of different sizes. If I resize and sharpen my proof version, then I'm not going to be able to use it for other print sizes and achieve high-quality results. To avoid this situation, I recommend duplicating the image.

At the beginning of this chapter, you duplicated your photo so you could adjust it for printing without affecting the original. At this stage the major upcoming steps are resizing and sharpening, both of which will be done for a specific print size. Now let's prepare a duplicate of the proof for a specific print. Then in the future when you want to make a different size print, you can go back to the proof version.

Go to Image > Duplicate. In the dialog box that pops up, leave the filename as is; then click OK.

19

Flatten the duplicate photo (Layer > Flatten Image). Because you're done with the proofing process, you don't need the individual adjustment layers anymore.

20

Save the duplicated image (File > Save). If you used my naming protocol for the proof file (step 4), then there is a "_P" at the end of the filename. For my final printing file, I add an *F* for "final" and the dimensions of the print. The filename tells me it's the final file for printing and the print size it's prepared for. I can make multiple final print files from the same proof version, each prepared for different print sizes. Keep this file in the same folder as the proof file.

21

Resize the photo to the print dimensions. Go to Image > Image Size. In the Image Size window, first make sure the three boxes at the bottom are checked (Scale Styles, Constrain Proportions, and Resample Image).

- **Document Size:** Enter the size of the print. You need to enter only the height or width, and the other dimension will change automatically.

- **Resolution:** Use 300.

- **Resample Image:** Choose Bicubic Smoother if you're making a print larger than the original size or Bicubic Sharper if the print will be smaller.

Click OK to apply the resizing and return to your photo.

Save As: Hilz_090331_5967d_PF 12x18.tif

Printing

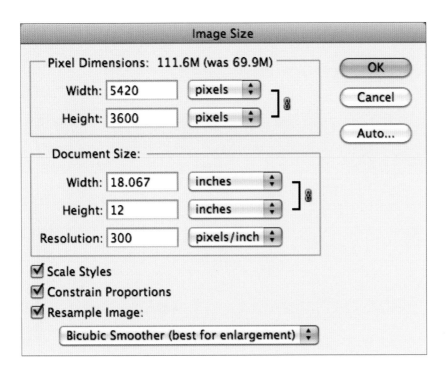

offer some guidelines, but the final decision will come down to how the photo looks to your eyes. As you sharpen more photos, experience will also teach you how to choose the right amount of sharpening.

Sharpening is not for fixing an out-of-focus photo, but for increasing the sharpness of an in-focus photo in the printed version.

22

Sharpening is one of the last steps before printing your final photo. After you sharpen your photo, you should not resize it or make any tone/color adjustments. Sharpening is applied based on the amount of fine detail in the image, the type of paper being used, and the size of the print

(which is why you already resized the image). You're applying the sharpening to the same file that you resized in the previous step. That's the only photo you need to have open.

Unlike many of the settings discussed for printing so far, there isn't one set of numbers I can tell you to always use. Sharpening is half art, half science. I'll

23 Let's apply the sharpening to a separate layer to make it easy to start over if needed. Duplicate the Background layer by pressing Command-J (PC: Control-J). Name the new layer **Sharpen** (double-click the layer name to change it).

24 Begin the sharpening process by going to Filter > Sharpen > Smart Sharpen. In the Smart Sharpen box, you can see a portion of the photo at 100%. It's important to view your photo at 100% to accurately assess how much sharpening you are applying. To change the part of the photo you see, click and drag within the photo box in the Smart Sharpen window. Or you can click anywhere on your photo behind the Smart Sharpen window. Wherever you click will show up in the box. If you'd like to see the entire photo at 100%, use this keyboard shortcut Command-Option-0 (zero) (PC: Control-Alt-0).

25

Next, we'll be working with the Basic settings for Smart Sharpen. Let's jump to the settings at the bottom of the window; we'll come back to Amount and Radius in the next step. For the Remove setting, choose Lens Blur. Then uncheck the box for More Accurate. If you check More Accurate, it will further accentuate fine details. This isn't ideal for all photos, so it's best to begin with this option unchecked. You can turn it on later to see whether it's a good thing for your photo. If you're sharpening a portrait, you definitely do not want to check More Accurate.

26

When you apply sharpening, you are increasing the contrast along high-contrast edges in the photo—for example, where a dark tone meets a light tone. This additional contrast increases the apparent sharpness of the photo. However, if you go too far, it results in oversharpening, which is not attractive at all. When a photo is oversharpened, the high-contrast edges have a thin, glowing outline that is called a *halo*. The photo also has a very "crispy" or "brittle" look, with everything being too well defined. To get a feel for what oversharpening looks like, increase the Amount and Radius to very high values.

Unsharpened

Extremely oversharpened

27

Now that you know what to avoid, let's look at suggested settings for Amount and Radius. Begin by setting the Amount to 100. Next, increase the Radius until you begin to see halos; then reduce it a little so the halos go away. The Radius setting will usually fall between 1 and 3. With your Radius set, go back to the Amount and fine-tune it. As you adjust these settings, it's helpful to have a reality check of what the unsharpened photo looked like. For an easy before-and-after comparison,

click and hold on the photo in the Smart Sharpen box. The photo will switch to the unsharpened version; release the mouse button and the sharpening returns. A quick click and release offer a good before-and-after comparison. This helps you make sure you're not going too far with the sharpening. You want to make the details in the photo better defined but avoid a dramatic difference between the before and after. Oversharpening can be easy, so if you're unsure, it's best to play safe and reduce the sharpening a touch.

28

Check the box for More Accurate to see whether this setting improves the image.

29

At this point the sharpness of your photo should be as you would like it in the printed version. There's one last adjustment you need to make to the Smart Sharpen settings. When your photo prints, it will lose some sharpness as a result of how the ink droplets are absorbed by the paper. To compensate, you need to purposely oversharpen your photo. I know I said how bad oversharpening is, but there's a reason for this oversharpening. How much to oversharpen depends on the paper. For matte or fine art paper, you'll need to add more sharpening than for luster or glossy paper. I recommend increasing the Amount 25% to 50%. For instance, if your Amount is 140%, you'd increase it to 165% to 190%. Finding the right amount will involve some trial and error in making test prints.

Amount: 139 %

Radius: 2.0 px

Remove: Lens Blur

Angle: 0 °

☐ More Accurate

Make a note of the Smart Sharpen settings you used, in case you need to delete the sharpening layer and try different settings. Click OK to close the Smart Sharpen box and apply the settings.

In the Layers panel, change the Blend mode of the Sharpen layer to Luminosity; this helps avoid enhancing any noise in the photo.

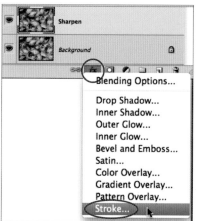

If you are going to show the edges of the photo when it is matted/displayed, you may like to have a thin black outline around the photo. This defines the bounds of the photo, separating it from the white paper surrounding it. This outline is particularly important if there is something white or very light (such as snow) along an edge. Without a border, it would be hard to tell where the white of the photo ends and the paper begins. Select the Sharpen layer and go to the Layer Style menu (fx) at the bottom of the Layers panel. Choose Stroke.

In the Layer Style window, use the following settings:

- **Size:** 3px
- **Position:** Inside
- **Blend Mode:** Normal
- **Opacity:** 100%
- **Fill Type:** Color. Use black for the color. If the Color box is not black, click the box and then click on black in the Color Picker window. Click OK to apply the Stroke.

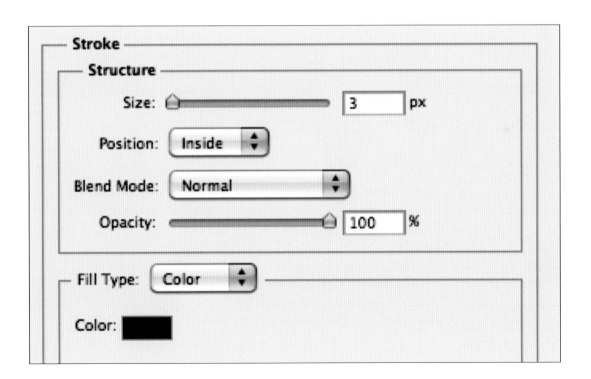

34

The Stroke Layer Style appears below the Sharpen layer. If you want to change the stroke, simply double-click the word *Stroke* to bring up the Layer Style window.

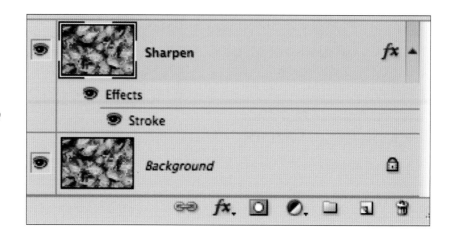

35

You're ready to print! You've already done your test prints for proofing the colors. The only question at this point is how the sharpening will look. If you're just starting to use sharpening, you may find you'll need to do a few prints to find the right amount of sharpening. The more you use sharpening, the easier it will be to apply the right amount the first time.

36

The steps and settings you used for printing your proof print are the same for your final print. Go to File > Print; then refer back to steps 13–16. When all the settings are selected, click Print.

37

Evaluate the sharpening of your print. If you need to redo the sharpening, delete the Sharpen layer by dragging it to the trashcan at the bottom of the Layers panel. Then go back to step 23 to repeat the sharpening process. If you wrote down your Smart Sharpen settings, you can re-enter them and then fine-tune from there.

That's it! You've now got a sharp print with accurate colors. Mat it, frame it, and enjoy!

Conclusion

ADOBE BRIDGE, CAMERA RAW, AND PHOTOSHOP are a powerful combination for your digital workflow. They can take you from start to finish, and now you know how to go about doing it. Granted, there are lots of steps to remember, each of which has its own options and settings, but if you commit to an efficient, streamlined workflow, your life will be easier down the road.

Make sure you do the not-so-fun stuff such as location metadata and keywords. You'll be glad you did when you need to find a photo a year after you shot it. Get all you can out of

Camera Raw because its clean interface will make going through the image adjustments easy. And when you need to go to Photoshop, keep everything nondestructive to give yourself the greatest flexibility in the future when you need to come back and do some more fine-tuning.

Enjoy all the ways you can share your images because after all the hard work you put into them, you deserve to be able to get them out there for others to see. And remember, the point of all this is for you to spend less time in front of the computer and more time taking photos!

Subject Index

Page numbers followed by *f* indicate a figure.

A

Adjustment Brush, 77, 78f–80f, 109
 Auto Mask, 82
 brush settings, 81
 Show Mask, 82
Adjustment layers, 112–116,
 112f–115f, 156f, 158f
 Hue/Saturation, 155
 layer masks, 150–154
Adjustments panel, 116, 116f
Append metadata *vs.* replace
 metadata, 99
Auto Mask, 82

B

Background color, 146, 147,
 151f, 154f
Backslash key, 153, 154f
Backup of photos, 14
Barrel distortion, 86
Batch Rename, 106–107
Black-and-white conversion, 74–75,
 136, 136f–137f
 combining color with, 138
 Targeted Adjustment tool for,
 137, 137f
Black blocks, 150
Black point compensation, 205
Blacks slider, 52, 53f–55f
Bridge, 180, 180f
 layout, 3–7
 metadata features in, 93
Brightness slider, 60, 61f, 117, 117f
Brush
 hardness, 147–148
 opacity and flow, 148–149,
 154–155

settings, 81, 148f
shortcuts, 147
tool, 146, 151f, 160f
Burn tools, 159, 159f

C

Camera Raw, 29, 32, 109, 110
 advantages of, 31, 32
 basic panel, 48
 black-and-white conversion, 136,
 136f–137f
 combining color with, 138
 Targeted Adjustment tool for,
 137, 137f
 blacks slider, 52, 53f–55f
 brightness, 117, 117f
 slider, 60, 61f
 check focus, 34, 34f, 35, 35f
 clarity, 64, 64f
 contrast, 61, 62f, 63f
 slider, 117, 117f
 Crop tool, 36–38, 36f, 37f
 exposure
 slider, 50
 warnings, 51, 52
 fill light slider, 58, 60f
 full screen mode, 31
 Hand tool, 35
 histogram, 50, 50f, 51f
 Hue, 118–119, 118f–119f
 Lens Corrections, 85–91, 141,
 141f
 multiple photos open in, 32,
 32f, 33f
 proportional cropping, 38–39
 recovery slider, 56, 58f

Red-Eye Removal tool, 46–48,
 46f, 47f
saturation, 38, 38f, 118–119,
 118f–119f
slider, 117, 117f
Spot Removal tool, 43–46,
 44f, 45f
Straighten tool, 40–43, 40f–42f
tone curve, 70–72
vibrance, 66, 66f
white balance, 48–49, 49f
Chromatic aberration, 89–90
Clarity, 64, 64f
Clipping, 50
Clone Stamp, 165–168
Cluttered panels, 7
Collections panel, 16, 16f
Color(s), 142, 142f
 handling, 205
 mode, 202
 and tones, 205, 206
Content Aware option, 163
Contrast, 61, 62f, 63f
 slider, 117, 117f
Crop box, adjusting, 38
Crop tool, 36–38, 36f, 37f
Cropping, proportional, 38–39
Curves, 121–122, 121f–123f
 add contrast with, 124–125,
 124f–127f
 Targeted Adjustment tool for, 132,
 132f–135f, 136
 Targeting tonalities with, 127,
 128f–131f, 131
Curves adjustment layer, 150,
 152
Curves layer mask, 150, 153

D

Darkening process, 159–162
Deleting photos, 21–22
Density of brush, 81
Destination tab, 174
Display options, 179
Distortion, lens correction, 86
DNG format, 14
Dodge tools, 159, 159f
Down arrow, 26
Downloading photos, 10
 Apply Metadata section, 15
 renaming files, 13, 13f
 source section, 12
 subfolders creating, 13

E

Editing of photos, 20
 check focus, 24
 deleting and rejecting, 21–22
 ratings and labels, 22–23
 review mode, 25–26
 rotating, 23
Exchangeable Image File Format
 (EXIF) metadata, 93
EXIF metadata, see Exchangeable
 Image File Format metadata
Export panel, 174, 174f
Exposure slider, 50, 117,
 117f
Extensible Metadata Platform
 (XMP), 14

F

Facebook, 174, 174f
Favorites panel, 8
Feather, brush settings, 81
File formats
 format option, 171f

PSD file, 168
Save dialog box, 169f
TIFF file, 168, 171f
Files, renaming, 13, 13f
Fill Light slider, 58, 60f
Filmstrip workspaces, 20
Filter panel, 5, 104
Flickr, 174, 174f
Flow, 148f, 149, 154–155
Folders
 panel, 9
 setting up favorites, 8
Foreground color, 146, 147, 151f,
 154f
Format option, 171f
Fringing, 89, 89f, 90f
Full-screen mode, 24

G

Gamut warning, 203, 204f
Global adjustments
 adjustment layers, 112–116,
 112f–115f
 Adjustments panel, 116, 116f
 Brightness and Contrast, 117, 117f
 Curves, 121–122, 121f–123f
 add contrast with, 124–125,
 124f–127f
 Targeted Adjustment tool for, 132,
 132f–135f, 136
 Targeting tonalities with, 127,
 128f–131f, 131
 Exposure slider, 117, 117f
 Hue, 118–119, 118f–119f
 Lens Correction, 141, 141f
 Levels, 119, 120f–121f
 Saturation, 118–119, 118f–119f
 Shadows/Highlights, 140–141,
 140f–141f

Smart Filters, 138, 138f–139f, 140
 Vibrance, 118, 118f
Graduated Filter, 83, 83f, 84f
 adjusting, 84
Gray slider, 119
Grayscale, 73
 conversion of colors to, 74–75
 Targeted Adjustment tool for,
 75–77, 76f, 77f

H

Hand tool, 35, 45
Hard edge Brush, 148
Horizontal bars, 4
Horizontal corrections of lens,
 86–88
HSL panel, see Hue, Saturation,
 Luminance panel
Hue, 118–119, 118f–119f
 adjustments, 73
Hue, Saturation, Luminance (HSL)
 panel, 73
 Targeted Adjustment tool for, 74
Hue/Saturation adjustment
 layer, 155

I

ICC profiles, see Printer profiles
Image options tab, 175
Image size and quality, 175, 175f
Image Size window, 206–207, 207f
Initial editing of photos, 20–26
International Press
 Telecommunications Council
 (IPTC), 10
 core section, 95
 fields, 95
 metadata, 93

IPTC, *see* International Press Telecommunications Council

J
JPEG, 168
 format, 29

K
Keystoning, 87
Keywords, 100
 panel, 100–103

L
Layer masks
 with adjustment layers, 150–154
 Brush tool, 146
 shortcuts to, 155–158
Layer Style window, 213, 213f
Layers panel, 111–112, 111f–112f, 150, 151f, 158f, 160f, 212, 212f
Layouts
 bridge, 3–7
 workspace, 7
Left arrows, 26
Lens Corrections, 85, 141, 141f
 chromatic aberration, 89–90
 vertical and horizontal, 86–88
 Vignetting correction, 91
Levels, 119, 120f–121f
Lighten/Darken layer, 160f, 161f, 162
Lightening process, 159–162
Location, downloading photos, 12
Loupe, 24, 26
Luminance, 74

M
Match print colors, 203
Media type paper, 202
Metadata, 175–176, 175f–176f
 EXIF, 93
 features in bridge, 93
 filter panel, 104
 flyout menu for metadata panel, 9f
 groups, 94–95
 IPTC, 93
 panel, 94, 99, 100
 placard, 94
 replace *vs.* append, 99
 searching, 105–106
 template(s), 96–98
 creation, 9–10
 skip, 99

N
New Layer dialog box, 159f
Nondestructive adjustments, 111, 200

O
Opacity, 148–149, 148f, 154–155
Options Bar, 111
Organizing photos
 collections, 16
 sorting, 15–16
Output panel, 180–183, 180f–181f
Output Workspace, 180–181
Oversharpening, 210, 211

P
Panels, 4
Paper size, 202

PDF file format, 187–188, 187f–188f, 191f
 document, 188, 188f
 Header and Footer groups, 190, 190f
 Layout settings, 189, 189f
 overlays, 189, 189f
 Playback options, 190, 190f
 watermark, 191, 191f
Photo Downloader, 11, 13
Photographs
 destination tab, 174
 Export panel, 174, 174f
 Facebook, 174, 174f
 Flickr, 174, 174f
 image options tab, 175
 Image size and quality, 175, 175f
 metadata, 175–176, 175f–176f
 presets, 177, 177f–178f, 179
 Save to Hard Drive, 176–177, 177f
 slide shows, 177–180, 180f
 web gallery, 182–183, 182f–183f, 185f
 Appearance section, 185, 185f
 Color Palette section, 184, 184f
 Create Gallery section, 186, 186f
 Site Info section, 184, 184f
Photos
 check focus on, 24
 deleting and rejecting, 21–22
 downloading, 10–15
 editing of, 20
 organizing, 15–20
 ratings and labels, 22–23
 rotating, 23

Photoshop
 black-and-white conversion, 136,
 136f–137f
 combining color with, 138
 Targeted Adjustment tool for,
 137, 137f
 file saving and file formats,
 168–171
 Layers panel, 111–112, 111f–112f
 Options Bar, 111
 retouching
 Clone Stamp, 165–168
 Spot Healing Brush, 162–165
 selective adjustments
 brush, 146–148
 flow, 149
 layer masks, 150–155
 lightening and darkening,
 159–162
 opacity, 148–149
 Toolbox, 110, 110f
Pincushion distortion, 86
Placard, metadata, 94
Presets, 177, 177f–178f, 179
Preview, 142, 142f
Print settings, 202–203, 203f
Print window, 203–204, 203f
Printer profiles, 195, 205
Printing
 16-bit data, 204
 color mode, 202, 203f
 colors and tones, 205, 206
 duplicated image, 196–197, 196f
 Image Size window, 206–207, 207f
 Layer Style window, 213, 213f
 Layers panel, 212, 212f
 media type paper, 202, 203f
 nondestructive adjustments, 200
 orientation, 204

oversharpened photo, 210, 210f
paper size, 202, 203f
preparation process, 196
Print window, 203–204, 203f
printer, 202, 203f, 204
process, 195
Proof Setup window, 198, 199f
resizing, 206, 207f
resolution, 202, 203f
scaled print size, 204
sharpening, 207, 208, 208f, 210
Smart Sharpen box, 208, 209f
Standard adjustments, 200
Stroke Layer Style, 214, 214f
unsharpened photo, 210f, 211
Proof Setup window, 198
Proportional cropping, 38–39
Proximity Match option, 163
PSD file, 168

Q
Quick Selection brush, 156f–158f
Quick Selection tool, 155,
 156f, 157

R
Raw files, 29, 61
Recovery slider, 56, 58f
Red-Eye box, 47
Red-Eye Removal tool, 46–48,
 46f, 47f
Rejecting photos, 21–22
Removing photos, 16
Renaming files, 13, 13f
Rendering intent, 198, 205
Replace metadata vs. append
 metadata, 99
Resample image, 206, 207f

Review mode, 25–26
Right arrows, 26
Rotating
 Graduated Filter, 85
 Lens Correction, 86
 photos, 23

S
Saturation, 38, 38f, 118–119,
 118f–119f
 in HSL, 74
Save dialog box, 169f
Save Options section, 12, 14
Scale adjustment, 86
Scaled print size, 204
Search options, 105–106
Shadows/Highlights, 140–141,
 140f–141f
Sharpening, 207, 208, 208f, 210
Show Grid, 142, 142f
Show Mask, 82
Show paper white option, 204
Size, 142, 142f
 of brush, 81
Slide options, 179
Slide shows, 177–180, 180f
Slider
 blacks, 52, 53f–55f
 brightness, 60, 61f
 exposure, 50
 fill light, 58, 60f
 recovery, 56, 58f
 tint, 49
Smart collections, 17–18
Smart Filters, 138, 138f–139f, 140
Smart Sharpen box, 208, 209f
Smart Sharpen settings, 211,
 212, 214

Soft-edged Brush, 148
Sorting photos, 15–16
Spot Healing Brush, 162–165
Spot Removal tool, 43–46,
 44f, 45f
Stacks, 18–20, 19f
Standard adjustments, 200
Straighten tool, 40–43, 40f–42f
Stroke Layer Style, 214, 214f
Subfolders, creating, 13

T
Targeted Adjustment tool, 71f, 72f
 for black-and-white conversion,
 137, 137f
 for curves, 132, 132f–135f, 136

for grayscale, 75–77, 76f, 77f
 for HSL, 74
Templates, metadata, 96–98
TIFF file, 168, 171f
Tint slider, 49
Tone curve panel, 70–72, 70f
Toolbox, 110, 110f
Transition options, 180

V
Vertical bars, 4
Vertical corrections of lens,
 86–88
Vibrance, 66, 66f, 118, 118f
Vibrance layer mask, 150
Vignetting correction, 91

W
Web gallery, 182–183, 182f–183f,
 185f
 Appearance section, 185, 185f
 Color Palette section, 184, 184f
 Create Gallery section, 186, 186f
 Site Info section, 184, 184f
White balance, 48–49, 49f
White reveals, 150
Workspaces, 7

X
XMP, *see* Extensible Metadata Platform

Y
yymmdd format, 13